FEELING

is the thing that happens
in 1000th of a second

By Christian Ryan

Golden Boy

also

Australia: Story of a Cricket Country (ed.)
Rock Country (ed.)

FEELING

is the thing that happens
in 1000th of a second

A Season of
Cricket Photographer
Patrick Eagar

Christian Ryan

riverrun

First published in Great Britain
in 2017 by

riverrun

An imprint of

Quercus Editions Ltd
Carmelite House
50 Victoria Embankment
London EC4Y 0DZ

An Hachette UK company

A CIP catalogue record for this book
is available from the British Library

HB ISBN 978 1 78648 682 0
EBOOK ISBN 978 1 78648 681 3

10 9 8 7 6 5 4 3 2 1

Text Design by Lindsay Nash

Printed and bound in Italy, by Lego

Forty-three Patrick Eagar photographs taken in the summer of 1975 and appearing in this book are numbered 1 to 43. All other photographs, by Eagar or others, are preceded by the year.

To Maria

"And I spent a fortune on" –
Patrick Eagar is rewinding forty-seven years to the last
job he ever had, working at a consumer rights magazine
called *Which?*, testing stuff – "testing electric blankets.
I think it was a record amount. Project officer one was
called. I'd get told to test whatever the thing is that
I'm testing and next work out how to test it and find a
laboratory somewhere to do the testing and supervise
the purchase of everything needed for the testing and
test it. Things like blankets, there was a British standard
they had to get to, so we built a machine which simu-
lated elbows and knees over a ten-year period to try
and destroy the electric blankets."

After that job all Eagar did was photography. One
late-winter/early-spring evening in 1975 the TV was
going in Kew where he, his wife, their baby and tod-
dler lived in a house of three bedrooms with a partition
slicing down the middle room to form a darkroom.
Probably the TV was turned to BBC2. A cricket high-
lights show came on covering the just-finished Ashes
series in Australia. In it was a slo-mo sequence of
Thomson, a bowler, and within this footage lay some
microsecond fragment, a tic, or sleight, of Thomson's
bowling action, something about the lateness with
which Thomson's bowling arm stayed hidden behind
his back – on the Eagar sofa this seemed new, startling.
Something else weird, he got an eyeload but couldn't
hold it, was in there too.

Boffins near the bottom of the earth welding scientific theory to photosonic cameras would shortly conduct the world's first semi-accurate inside-the-stadium testing of fast bowlers' speeds. Eight months ahead of them Eagar was hatching his own system. Coming up to his fourth season shooting international cricket he was only now turning thirty-one, possessed of an older photographer's seriousness maybe but his energy felt big and ideas were hitting his skin in clean lines, ideas which wrongwayed ordinary thinking, like this speeds experiment thing. It occurred to him he could sit facing the action sideways with two cameras next to each other both photographing the same ball, only one of the cameras would go off fractionally late. Back home he'd position a sticky thin white paper strip on his record player's turntable. Photograph it spinning. That way he'd calibrate the second camera's time delay. Which was 0.045 sec. Next, measuring the distance traversed by the ball between the first and second photographs, based on the solid assumption a cricket pitch is twenty-two yards long, and culminating in some straightforward multiplying and dividing, he'd deliver an historic speed estimate.

In his head Eagar was roughing and mapping his system out around February/March/April – about the time that highlights show went to air, exact programming details are hazy.

Then in May he photographed fourteen days' cricket, county games mostly. Bournemouth, Hove, Oxford, The Saffrons, The Oval (four times), Canterbury. He grooved tyre marks into the roads round England's south. In Southampton he shot Roberts of Hampshire bowling. He flipped to the back of the Roberts contact sheet, which is a first proof, like a rough draft, and wrote 83/85 mph. It wasn't anything stupendous. But Roberts had a busted finger. On the 13th of the month, a Tuesday, the *Guardian*'s wine and cricket correspondent John Arlott noted Eagar "renders cricket such a service as no one else in his field has ever done before".

Fourteen days of shooting in May plus a day in and out of the darkroom after each of those days to develop the film and sort it. Twenty-eight days that added up to, and on the 29th an Australian cricket squad landed at Heathrow with tanlines hanging out of their shirtnecks to play in an eight-team World Cup followed by four Test matches against England. Thomson disembarked wearing a caramel-coloured suit jacket. Blue-eyed and clean-shaven, he was like a pig farmer shackled in an LA lawyer's get-up. On London streets he signed autographs.

That highlights show from Australia: Eagar was there. He followed that tour around three out of five mainland state capitals, photographing Thomson at each

stop. He depicted the before, during, after and aftermath – batsmen numbed, stung, winded, prostrate, upended and writhing like insecticided cockroaches – of Thomson's bowling action. Six stages Eagar got, starting with Thomson's knuckles dangling low nearly scraping pitch crust during the cocking of the catapult; then, drunk-eyed at the point of release; mouth agape post-release; Thomson on the follow-through, a bourbon smoothness; Thomson yawling an appeal at an umpire; Thomson enquiring after Fred Titmus's health lest he'd knocked old sod Titmus's knee out of its socket.

Still Eagar felt his man had given him the slip.

Next morning, a bitter freezing morning, the 30th, was his next chance. The Australians were holding their first training and momentarily Eagar set up behind the Lord's practice nets catching Thomson front-on, right knee braced and a jetlag snarl. Pretty striking photograph. But Thomson's bowling hand's sawn off – concealed, under the cuff of a long-sleeve jumper he'd wrapped on top of an additional sleeveless jumper.

So, another day's sorting and developing film, six to seven minutes per roll, and eight rolls could be done at once, after which they went in the fixer followed by a thirty-minute wash and then they had to be dried and the drying could take up to three hours, quicker if you'd

used metho, but dry them too quick and they'd curl up, and the day after that Eagar with his two cameras returned to Lord's. The terraces and the balconies and the nooks and the posh seats and the uncomfortable seats were half filled. Middlesex and the Australians were staging a 35-over friendly match on a shrunken, misshapen playing area, the pitch too close to the tavern-side boundary, helping account for the Australian batsmen's seven six-hits, four of those sixes landing on the road, the umpires fishing replacement balls out of their coat pockets, a collection that whipped round the crowd raising £1,092 for Middlesex's veteran wicketkeeper, Murray, that's how friendly things got.

Then Thomson bowled. On a slow pitch. Him whirling in off his full-scream run-up. Wide ball to start with. Numerous times he overstepped the creaseline. No no-balls got called. Brearley, batting, couldn't tell if Thomson was flatout but knew enough to know Thommo scary-ish was scari*est*. Speed was also preoccupying Eagar. He photographed Thomson's second, fourth, sixth, eighth, tenth, twelfth, fourteenth, fifteenth, sixteenth, seventeenth and eighteenth deliveries, twice each ball, once on each camera,

doing similar for another bowler, Lillee, down the opposite end. The bowler in these photos was miniature as a bug on a flywire. Taking a magazine-worthy action picture was nowhere among Eagar's priorities. Eagar's absorption was pure and total in his speed measuring experiment. And abruptly another instinct took over and he went looking for the moment or thing on TV he had seen. Except he *hadn't*. Except...which moment? Thomson turned and began his fourth over. Making his camera go in closer on Thomson, Eagar photographed all six balls, and one of the balls two times, the whole while hoping without knowing.

Frustration – Thomson's fourth over proved the last of his spell – was directed silently at Chappell, the captain who'd dragged Thomson off, plunging to deep disappointment later as Eagar pored over the negatives, still wet. Travelling round Australia, he lamented, he had been photographing Thomson a twitch too late and it only made this fresh different stuff-up harder to take. He pored and regretted. He counted to six. Gone too early, too early, 1, 2. Again, hell's teeth, the elusive moment blown, 3, 4, 5, and on the thirty-second frame of the contact sheet, which was a photograph of the last ball of Thomson's final over before his captain replaced him, was this,

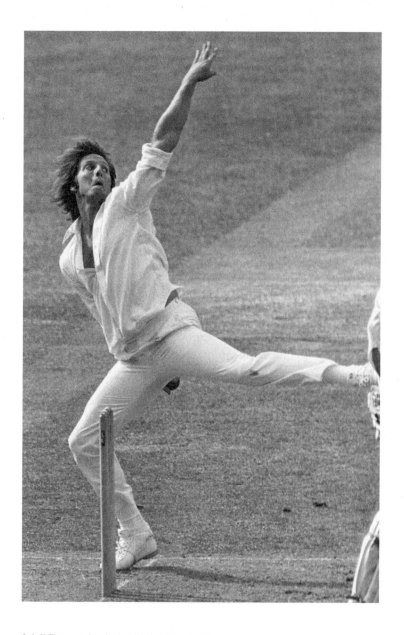

1 Jeff Thomson bowls, Lord's, 1st June 1975

showing what sports photography – live, unstaged, not cooked up between a photographer and a performer – could do, be.

Patrick Eagar is a laughing man whose laughter book-ends his sentences and cushions their middles. It is a gentle, cultured, often self-effacing, kindly laugh. He really likes to laugh. In 1975 when he was still wearing glasses his face was a scientist's face unscarred by sun and not chipped at by the elements. Not a photographer of the outside world's face. Lips that looked strict when pursed. Skinny – his 1.8-metre body is still in good shape – he sat low with his two long legs tucked under and in between and colliding with the tripod's three legs. The way some laughing people's laugh reveals them, in his laugh there are clues.

The Thomson photograph was an instant hit. It ran in the *Sunday Times* of London. Eagar then airfreighted a big copy as requested to Melbourne's *Age* and seven months later visited that paper's office hunting for Ron Lovitt's photograph of the 1960–61 Gabba tied Test climax. The original Lovitt negative, Eagar was duly informed, was lost or broken but a copy sat in a safe where the newspaper kept its most treasured images

from history and would he fancy a squiz? Eagar was chaperoned to the sacred safe. And look, pointed out this *Age* staffer, there's the tied Test photo, this one's of the 1972 Elizabeth Street flood, here's a Jeff Thomson action shot taken recently by *us*…

Bright cloudy days were Eagar's favourite, the sun not too high overhead, creating a soft, diffused light. In this instance, soft sunshine illuminates Thomson's action at the moment of maximum exertion with the face a thrilling accident, sinewy, bony, grotesque.

The *Times* and *Radio Times* TV guides of the time say at no time was any Ashes highlights show broadcast.

Timing was everything: the ball materialising ghostlike between Thomson's thighs. It took slo-mo, or slower – a photograph – to see that.

"Without that," says Eagar, "the photograph was nothing."

"Let me," I say, "show you another."

"Go on."

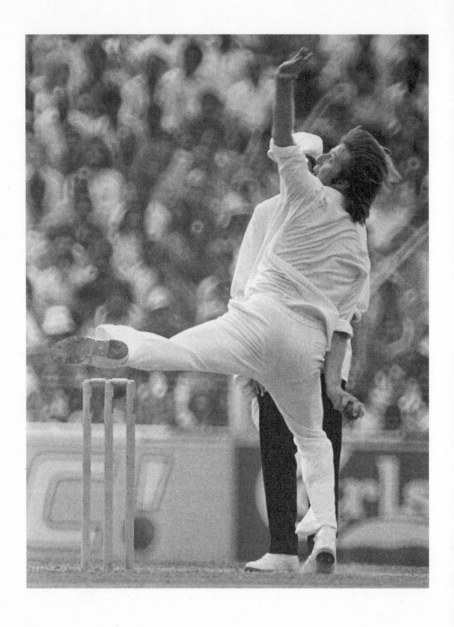

2 **Thomson from the Vauxhall End, The Oval, 14th June 1975**

"Thirteen days later was a World Cup group game, Australia playing West Indies, you took this…"

"Again I am replicating," Eagar says, "what I'd seen on television. It is exactly the same moment. You could say one was looking for the forward leg at its peak stretch. I'm absolutely certain, now, that what I'd seen was the ball and his hand in that extreme position between his legs which you never saw any other bowler do."

"So on this second occasion did you specifically go trying to capture it from the reverse angle?"

"Um, look what you haven't seen are all the errors."

"Because what it put me in mind of was George W. Beldam photographing Victor Trumper."

"The stepping-out-and-driving one? Oh no. Oh, OK."

"Almost like Beldam was thinking Got him, now I'm going to *get him from behind*."

"Sure," says Eagar.

"That's what you and Thomson put me in mind of. Am I delusional?"

1905 Victor Trumper by George Beldam

"With positions," he says, "when you got to the ground there were certain places you were allowed to go and you'd select where based on, OK, the action that might follow but also the lighting, the background. So at The Oval I often went to that position. Nice for backgrounds, nice for lighting and it was different from other grounds so you got variation. Then as Thommo bowled I would have said 'OK, I'll look for this'. I don't think I would have had in mind it was going to yield exactly *that picture*. But, you know..."

A week later, another echo. This one was a pre-echo and also a cross-referencing self-echo – some kind of visitation dictating Eagar's movements except that is logically impossible although...

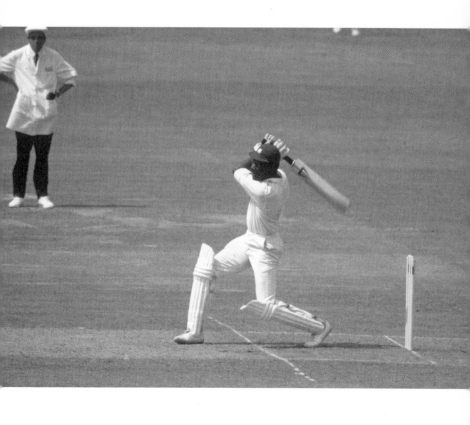

3 Clive Lloyd drives, Lord's, 21st June 1975

"Lloyd," says Eagar. "World Cup final, 1975."

"With Dickie Bird umpiring there at square leg."

"Yes."

"See, to me it feels almost like a prequel to your Steve Waugh photograph of 1989 with…"

1989 Waugh blocks,
Lord's, 24th June. By Patrick Eagar

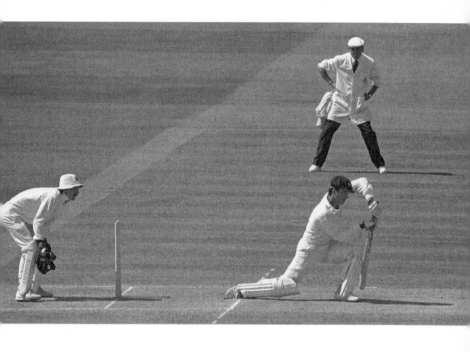

"...Bird," I say, "in very similar position."

"Bird. Yeah. Great. At Lord's this was quite a good position to work from, beside a scoreboard and with no competition from the public or other media. It's one of the positions formerly used by Sport & General" – the photo agency that co-hogged, with Central Press, the exclusive photography rights to Test matches in England until 1972 – "but when Sport & General gave way to everybody the MCC were a bit concerned about where photographers were allowed to go at Lord's. You know, not too many in the pavilion. Not too many

in sensitive places. This particular angle they didn't mind at all. OK it's square, but I had no problem with that, in that while it was limiting at Lord's you didn't work from that sort of position at the other grounds. So you were getting variety. And I was always wanting variations. So I found myself at square leg, square cover very often. And so I guess the Clive Lloyd/Steve Waugh thing isn't such a big coincidence but what is was Dickie Bird, and the fact that, because Lloyd's left-handed and Waugh's right-handed, Bird was in the background at either end in each case. That's an intriguing – *intriguing* – juxtaposition."

"One's a left-hander, one's right. One's playing a classical defensive stroke," I say, "and the other's playing a classically swashbuckling aggressive drive. There is an inverse element happening, isn't there?"

"One black-and-white photograph, one colour," says Eagar.

Also, one black man, one white man – that realisation didn't drop until afterwards when our Melbourne/ London Skype connection got too flaky and we called it a night (me)/early afternoon (him).

CR: "Do you notice echoes within your own work? How awake to that are you?"

PE: "I ought to be able to find others."

CR: "Here's another photograph of yours, again from 1975, Kallicharran is batting."

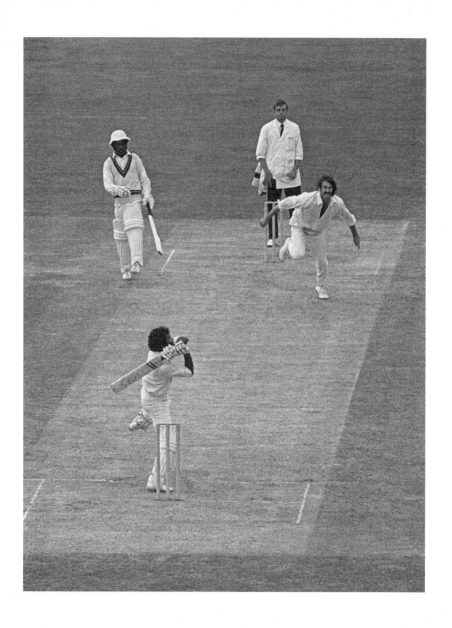

4 Kallicharran hooks Lillee at The Oval, 14th June 1975

PE: "Gosh. Wonderful."

Pawpaw could be bought in the outer that Oval Saturday in London. Even *Wisden* could not resist racial profiling the boisterous crowd – "excited West Indian supporters" mainly plus "Australians from Earl's Court". The photograph was taken via remote control on a faraway unattended second camera whose shutter Eagar released by choosing the right nano-instant to activate a radio transmitter device. Eagar himself, his physical self, was crouched at long leg, wrong position for a Kallicharran hook stroke and he knew it, over the shoulder of the fielder Max Walker. Spectators yelled "bowl im de bouncer, man" and Walker turned and replied "no, he's a non-recognised batsman" which was, on the surface, a little bit funny, made funnier by Kallicharran hooking and driving off consecutive deliveries – there was also one thick edge – 4, 4, 4, 4, 4, 1, 4, 6, 0, 4, OUT off a glowering Lillee.

"And in this one the echo is within the same photograph. You've got Kallicharran…"

"Right."

"… with his left leg in the air and then you've got the non-striker, Roy Fredericks, who's also lifting his left leg up."

"You can add to that," Eagar says, "Dennis Lillee has got his right leg in the air."

"True, it's an intense moment of Lillee as well, his eyes following the ball's path. And Bird – you can sort of see Bird's eyes fixed on the ball flying away. Looking dazzled, numbed. If they were little men you were manipulating with your fingers you couldn't arrange it any better: those two left legs, that symmetry. I guess you can't plan for that. Can you?"

"No, sheer luck."

There's chance, there's planning, and above and askew from those two grey zones exists another – there's dreaming – and unravelling which is which is which, in other words how did Eagar do it, is the crux of experiencing, being with, an Eagar photograph. It's also futile because it is incalculable and neither is there any knowing if, when Eagar says "luck", or "coincidence", that's him mis-steering and pushing us off the scent.

Dreaming, the greyest grey, is a photographer conjuring in his head a scene and pre-adjusting, pointing his camera just so that should the dreamed scene transpire he'll capture it.

He continues.

"It was a photograph that, as a photographer, you almost don't know why but you naturally say 'that photo works'. And I guess it's a photo that works. I remember this quite well because it was such a fun day and I was frustrated. Where I was, I wasn't getting the pictures I wanted, Kallicharran had his back to me, so I was relieved to go to the remote-control position and find the elements of this – the batsman, the bowler, I guess it sits as a quiet little composition quite well. One of today's frustrations is that because of TV paying more money and having more and more influence, to the point that often there have been cases of television people taking over positions once occupied by photographers, you don't have the same flexibility at big matches anymore. You have a certain amount. Whereas back then you knew from experience the angles that were going to…

"Although with a" – Eagar swivels back – "remote camera you didn't have flexibility: to move it. You'd set it up at the beginning of the day. That's what you had

until the film ran out. And it had to work at both ends. Say, with the batsman at the far end, if a bowler's bowling over the wicket he isn't going to block you but the backing-up batsman might, when you think about it.

"See I think honestly, Christian, it's a lot of luck. I can't say anything else.

"And if we're being critical it's probably taken from slightly too high an angle. I remember thinking when I looked at the contact sheet: I'm too high. I wish I could have got something lower down, maybe..."

CR: "But you've got a—"

PE: "...maybe not."

CR: "—lovely angle of Fredericks from where you are."

PE: "True. You wouldn't want to spoil that. OK. I'd leave it. Good one. Got any more?"

There was a season – 1975 was the season – when most mornings it seemed like Eagar was stepping out of the house, getting in his metallic-blue Renault 16 TS with the sloped boot, a fairly recent purchase, driving to some cricket ground and taking a photograph unlike any cricket photograph anyone had seen before. So far we have seen four, out of sequence, to catch the day-by-day gist of that period go back. To the start: the second-last morning of May, the aforementioned cold session at the Lord's practice nets when Eagar's ambition to capture the full kapow and ouch of Thomson's bowling action was thwarted by Thomson's hand being buried beneath the sleeve of his top jumper. For a moment Thomson appeared before Eagar with the outermost layer off. Thomson was standing, so close they were touching, beside Lillee, one's are the supple fingers of a cellist, dainty nearly, and his partner, though powerfully built, has a footman's humble air, these two most glamorous cricketers on earth. On an exposed arm, fair hairs are sprinkled. Something of their beginnings comes through, an asbestos house, anxiety nosebleeds, magpies that swooped, too shy to dance, tensed up and leaving pages blank at school exams, sport all weekend, eaten-out soup cans for golf holes, zonal hockey, fishing, soccer in the Protestant Churches League, cricket in the Municipal and Shire competition.

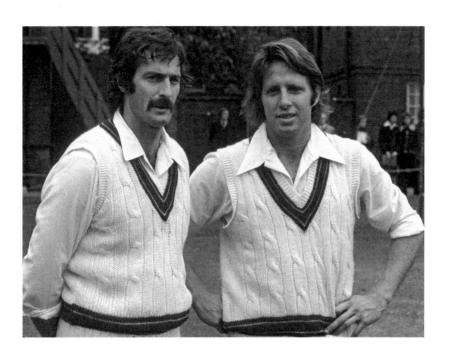

5 Lillee & Thomson, 30th May 1975

Cricket's uh-oh duo were at the midpoint of their two-year rule. A Jill Evans of the *Mirror* gushed and marvelled at Thomson's past pulling of fourteen women in twelve nights, "models and beach beauties" being his "favourite", this *Mirror* being the same sensitive organ which got twitchy on the occasion of another star's first tour of England in 1956, Liberace, who was "the summit of sex – the pinnacle of masculine, feminine and neuter. Everything that he, she, and it can ever want."

Lillee and Thomson like Liberace transcended ordinary fame.

But check out the background. Six onlookers: none are looking.

Eagar took the picture on a Friday, went to Eastbourne on Saturday for a match, and was back at Lord's on Sunday, the same Sunday he found what he had been wishing for – Thomson at full stretch [1] – not actually realising he'd got it until the Monday/Tuesday. Wednesday landed him in Southampton for a Benson & Hedges Cup quarter-final. Ian Botham of Somerset was raw and pre-facial hair. Eagar had encountered Botham twice before, as a kid nobody working on the Lord's groundstaff and kid Tarzan a summer later, in Taunton, bowling Barry Richards in the morning and

losing two teeth yet still striking the winning runs in the afternoon. This third encounter, Eagar achieved an action portrait, Botham square-driving off tiptoes, the acme of fluidity, en route to a score of 7, Eagar thinking as he snapped him "here's that kid again".

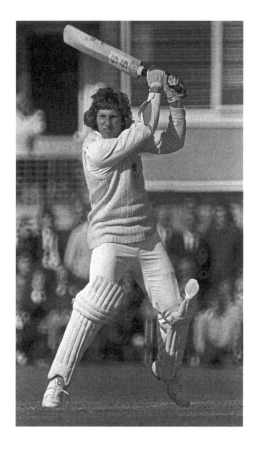

6 Botham v. Hampshire, Southampton, 4th June 1975

And two days after that Eagar was at an exotically guestlisted cricket do positively intergalactic in scale, and crowded around him was a smorgasbord of Zulfiqar, Gundappa, Glenn, Hedley, Rick, Duleep, Rohan, Vanburn, Viv and Andy, and Eagar was saying to Andy, "Andy, get Viv over here and I'll take a picture of the two of you."

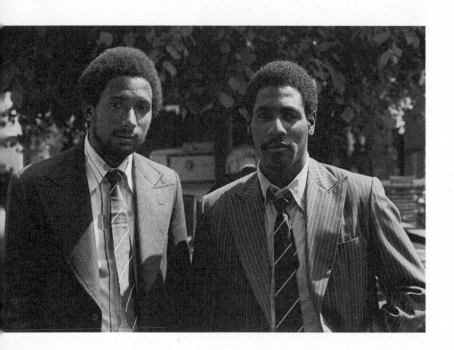

7 Roberts & Richards, 6th June 1975

And – "god," Eagar is casting back now, "look at those suits."

Summer 1975: the first World Cup, cricket's second global event. In 1912 it had been the Triangular Tournament and dogmatically white – England, South Africa, Australia; 1975 was an octangular. Players from all eight teams met the Queen, two princes and lined up on Buckingham Palace steps before heading to the reception at Lord's. The Grace Gates are over Andy Roberts's right shoulder.

No Antiguan had ever represented West Indies. Suddenly: two. They roused Eagar's curiosity.

"Andy," Eagar says, "was never that talkative and Viv was going through either his shy period or the Smokin' Joe bit, I'm not sure which." Despite the frugality of the era he would go on to photograph Viv many thousands of times. This was the first. "Viv's looking" – Eagar's on his laptop, zooming in – "not too threatening. He got a scar, didn't he? A bit later on."

The scar was a faint rubbery wedge of skin on his left cheek above the line of the nostril.

"I'm pretty certain," Eagar is saying, "this is just one picture, I only did one frame, as I didn't get long with them. Difficult to tell. You rationed your film anyway. You were aware not only of the cost, which added up, but also the bulk of it, and if on a shot like that you took six or eight pictures then did the same for everybody you'd get through four or five rolls of film, all of which had to be developed and one was coming off the back of the generation that shot on plate cameras, remember. On a plate camera you took one picture, that was it."

Any Eagar/Viv photograph requires the strapping on of twin-glimmer eyeglasses. Is what we are seeing a picture *of* Viv? Is it a picture *by* Eagar? Out of all the world's cricketers it was Viv the camera rated coolest. Yet Viv owed plenty to the one it was, Eagar, who made photographs out of him. They are photographs with a split personality. Who's dominant depends partly on context: say Americans re-take to cricket and Andy and Viv [7] someday find their way onto a Meatpacking District wall. In that setting, neutral, Eagar/Viv are 50/50 presences. (Leave Andy, inscrutable and broody, out of it.) Partly, opinion is personal and hinges on your

answer to this: whose presence matters most upon the slamming of a cover drive, Viv's for playing the stroke or Eagar's for preserving it?

"Actually," Eagar is correcting himself a minute later, "I took two frames. In the second frame Andy's straightened his tie and Viv is looking at him."

Some subtle twist in perception separates this Viv from later photographs. Time is the chisel. Viv in mid-'75 was learning, not the Master Blaster yet; it was Eagar on fire; the power balance is shifted. Viv with his flawless skin was a youth of seven Tests, seven more than Botham had played, one fewer than Roberts, one more than Thomson, whereas Lillee had played seventeen, and Eagar had photographed the lot – five superstars-to-be in eight days, a rate nearly commensurate with Thomson and his romancing of sand-between-their-toes women. Call it Portrait Week. Lillee and Thomson, a charade of innocence; Roberts and Richards, innocence and malevolence; Botham at the moment of innocence fading. Another portrait, taken in the sun-splintery last gulps of the 1975 cricket season, sat unnoticed and rarely published – it was on a solitary ghosted book's cover – for thirty-seven years until the day that Tony Greig died when it came somehow to define him.

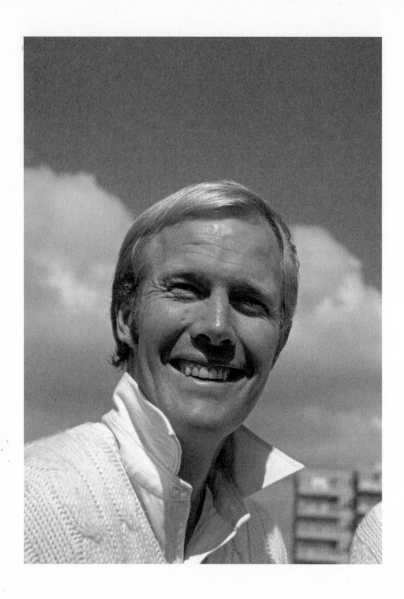

8 Tony Greig in Hove, 15th September 1975

"I was in Hove and the weather was OK and there was a bit of a match on and I'll tell you what else," Eagar recalls, "Greig was doing.

"He had been modelled by Madame Tussauds. A wax-work was made of him. And he'd dressed up in nice clean gear, because of the Madame Tussauds thing obviously. And he'd done his hair. Seeing he was in posing mood I said, 'Can I do some shots?' This one you're looking at with big blue sky above was because a well-behaved photographer like me had to leave space for them" – them being Eagar's main employer – "to put THE CRICKETER all over the top." Most months Eagar shot the magazine's cover.

"And I always remember Greigy, always accessible, I don't think he ever said 'no' to 'can I take your photograph?' Ever. And that's unusual. Except he'd also, always, add something – *but be quick.*"

The bit of a match on was Sussex playing Lancashire. On the day Eagar photographed him, day two, Greig bowled eighteen balls, leapt too close to the pitch's middle in doing so, and the umpires ordered him off bowling again. Eighteen balls in a day's work. "The following winter he was playing for Waverley in Sydney and I arranged to photograph him on the beach with

his daughter," says Eagar. "As I say, 'yes but be quick' he'd reply although when we went down the beach he seemed happy to give the morning away. It was a quiet winter. England didn't go anywhere that winter. So he wasn't in the limelight. Was only playing for a Sydney suburb. I think the idea it might be publicised in some form or other appealed to him. Looking again..."

Eagar stops. "Look. There's another shoulder. In the bottom right corner: another sweater. That's his Madame Tussauds. It looks like another player. It's not. It's another Tony Greig."

Back when Eagar was twenty-one, out of Cambridge (social anthropology, science) and fresh from a summer at the *Cricketer* photographing cricketers and cricket grounds he met Simon Guttmann. Guttmann was seventy-four when they met, and invariably they'd meet long past midnight at the Cumberland Hotel between Notting Hill where Eagar was living and the photo agency, Report, that Guttmann founded and ran. Not until an apprentice photographer was "in" – spiritually, morally – plus "up", for adventure, did Guttmann desire to let them in or up to his top-floor office via two flights of barren stairs at 411 Oxford Street, near Selfridges. "He was proud of the address," Eagar remembers.

"And he had an assistant, Helen, who was long-suffering. He embodied all sorts of rules that, yes,

I appreciated. We never used flash. The subject should never really look at the camera."

The office was small. Guttmann was small. Like a spider, like a homunculus: these were the comparisons made. Guttmann's chair was hard. The look in his eyes was hard, penetrating. High was his forehead, he had wire-rimmed glasses, and from under and behind these he glared. Irritably, or with charm. The office was chaos, the man whose office it was blazed with theories and giant ideas, and as far as is known or can be reliably back-told he had been that way since birth, in 1891, the only child of a well-off Jewish family in Vienna, a city they left because of anti-Semitism for Berlin, where Guttmann was eleven when his father died, and where as a young man Guttmann was all this – an art scene go-between, a poet, a socialist, a student of the history of civilisation, a philosophy/literary club leading light, a literary cabaret organiser, an influence on the poet and playwright Georg Heym, a magazine editor, Walter Benjamin's friend. World War I interrupted all that.

"In the February cold snap of 1915, and on the advice of a doctor friend," write Nicholas Jacobs and Diethart Kerbs in the journal *German Life and Letters*, "Guttmann took numerous warm baths and then spent time unclothed, exposed on a Berlin balcony. Army doctors

subsequently diagnosed severe bronchitis, as a result of which Guttmann was allowed to convalesce in neutral Switzerland" – first in a sanatorium in Ascona.

Later in Zurich. Drank coffee with the Dadaists. "One of the quickest and," Hans Richter said of Guttmann, "best conversationalists." Met the poet Mayakovsky in Moscow the same year, 1923, that Mayakovsky and Lili Brik called a turbulent two-month hiatus on their ménage à trois incorporating Brik's husband Osip – yes Lili loves me, Mayakovsky decided, on balance, but it was consistent with her "love towards everything" and

> if I come to an end I'll be removed, like a stone
> from a stream, and your love will go on washing
> over all the rest. Is this bad? No, for you it's
> good. I'd like to love in that way.

Guttmann is said to have stayed a fortnight in the house of Lili and Osip. On departure he smuggled to Berlin with him early Soviet films. Public showings were held. Thus say Jacobs and Kerbs: "Guttmann became the initiator of German–Russian film relations."

Photojournalism's day loomed. Instead of a single posed image, multiple photographs could appear, interlock, work in tandem with the words to lay bare one subject. Photostory this was called. Guttmann was an early inventor and commissioner. "Secretary" of Dephot

he dubbed himself. Dephot was the picture agency he started to supply Germany's illustrated publications. A photostory's subject did not have to be some celebrity pap. It could be flies-and-grime real life. At Dephot it was the photographers who were tomorrow's celebrities: Felix H. Man, Kurt Hutton, Otto Umbehr. Pegging and refilling stuff in the Dephot darkroom was Robert Capa, who Guttmann called *laufbub*, meaning gofer. Guttmann lent Capa a Leica. Guttmann groomed Capa hardball-style, slow. Once a bitching Guttmann critique of some early Capa photos was queried. "Well," replied Guttmann, "I can't just tell him he's a master."

Dephot's thrills-filled, budgets-sieving lifespan went from 1928 until 1933, when the Nazis sacked most major editors, installing lapdogs. No cops would be ransacking Dephot's portraits archive on the trail of left-wingers: Guttmann wrecked the archive. Then he was on the move again, shadowy, circuitous, through Vienna, Budapest, Paris, Palavas-les-Flots (translating for the French Resistance), Balaruc-les-Bains (arrested and interned), the Pyrenees, Barcelona, Toledo, Lisbon. Last stop London. He formed Report in 1946 to document the working-class struggles of the ordinary and the ignored, those "terrible years in Britain",

in Guttmann's own words, "and who fought and why". He believed photographs eluded the mind. They arrowed through the eyes to the heart.

Inge Morath began an apprenticeship with Guttmann in 1952. As an anti-Hitler youth she had been put to work at Berlin's Tempelhof airport, which was bombed often, alongside Ukrainian women workers, who were deemed expendable. Later she'd explain her path to taking photos. "My native language, German, was for most of the world the language of the enemy, and although I was able to write stories in English or French it did not touch the roots. So turning to the image felt like…an inner necessity." For Guttmann she heated his shaving water. He dictated his letters to her. She, fatigued of this, snapped and he rebutted: "But everything I know about photography – how to approach a subject, how to build a story – is in those letters."

Another apprentice Grace Robertson watched him tread on some enlargements she'd painstakingly made, and as his feet stomped Guttmann's lips curled: "Kurt Hutton would never have taken pictures like these."

Enter Patrick Eagar – a fellow Cambridge graduate suggested to Eagar that he go see Guttmann.

"The deal with Simon was we halved the expenses," says Eagar. "And we halved the profits. But they were minimal."

Guttmann was "a great man for contacts". Also "highly intelligent". He was like "a walking history book. The problem with Simon," thinks Eagar, "is he was his own worst enemy. Never made any attempt to curb his German accent, which could be extreme. Wanted to inflict on almost any editor or magazine his own conditions – which again could be EXTREME. The great thing was this fund of ideas he had. He was well read, researched and should have been far more successful. I don't think you could say in the overall scheme of things his business in London was very viable."

Extreme – an example: in Dephot days he'd once met with a *Der Welt Spiegel* editor who had on a dress, and the dress had epaulets, a touch too militaristic for the taste of Guttmann who, reaching for nearby scissors, hacked the epaulets off.

"Probably his greatest coup was arranging an interview with Ho Chi Minh himself during the early stages of the Vietnam War," Eagar says. "In Hanoi. In the UK

we were neutral, in a sense, supporting the Americans, tokenly, but no one ever went to fight there, unlike the Australians or New Zealanders, and through a Paris connection Simon was able to send a film crew. Which was one man, Romano Cagnoni, a reformed paparazzo and damn good photographer, doing the stills, Malcolm Aird working the cinecamera, and a famous journalist named James Cameron doing the voice and the writing.

"This was 1965. He got the Ho Chi Minh interview: astonishing. And he got pictures of the Americans bombing Hanoi and quotes like *if you stop sending your planes over we'll stop shooting them down.*"

A passage in James Cameron's book *Witness* paints the mutual dependency in Hanoi of the people, riding two or three to a bicycle; also, the Red River's redness, a warm tomato soup red, and the big board in the park by the lake keeping count of US planes gunned down daily, which looked

> like a cricket score-board…That day they
> claimed no fewer than ten – in one day, could it
> be possible?

"Simon sent me," says Eagar, "to South Vietnam because the guys who had been to the north, who were probably better workers than I was, had the stamps and the passport and weren't going to get into the south, I don't think."

What happened was British prime minister Harold Wilson had relented – agreed to dispatch a medical team to a Saigon children's hospital.

"About as unpolitical a statement of support as you could make," reckons Eagar, "and I went out with them and photographed their early days. From the time they arrived at the hospital. Things they were able to do. Then I followed the civilian population in Saigon, the effect of the war on them. I got on with them really well. Oh god it was a steep learning curve. Actually I wasn't very good at it. I've never been that good a newshound. Because I always felt sorry for the victim. Even in cricket, remember Mike Atherton had dirt, or something, in his pocket and for two or three weeks the media chased him – I thought poor sod, leave him alone. What was needed in Vietnam was the ability to make your own stories. To be honest I was a bit out of my depth. But I got some good stuff. And they got published. And I had four months in Vietnam, thanks to Simon. August until December '66. Again we didn't make a load of money out of it and we spent a heap. I ended up with an Australian medical team, they were fun, in the Delta. They were nice and looked after me. We had moments there when people came in who'd been blown up and had to be patched up."

A year on: December 1967. The hour was late at the Cumberland Hotel and the conversation went –

SG: "My dear, tomorra ve are going to photograph an extraordinary man."

PE: "Yes, Simon."

Late November 1932 was the date a genius future war photographer, Capa, got his first byline, Guttmann putting Capa on a train to a Copenhagen hall to photograph from a few feet away with his little Leica the exiled Leon Trotsky broach "The Meaning of the Russian Revolution" before an audience of two thousand students who clapped rousingly at the finish.

Now Guttmann was explaining to Eagar how he was sending him to photograph Oskar Schindler.

Thin ribbon like old cassette tape, as real as reel, threads that Copenhagen night to this. This pre- the Steven Spielberg blockbuster night. "This Mr Schindler," said Guttmann, "is going to be in London."

They went together, Guttmann and Eagar. It was a party or discreet press gathering for Schindler. They gatecrashed it. Eagar had a Leica. Single lens only. They saw Schindler and bumped into him, or up to him, and Eagar got a close-up of Schindler gazing off to the left of the Leica with attentive eyes. After that Eagar and Guttmann got shown the door probably. Eagar forgets.

"It is not an exciting shot. But it exists," he says. "It is just about the only photograph I have ever seen of Schindler."

It was dark in that room where he took it.

No flash. Using flash broke Guttmann rules.

He looks again at Tony Greig.

Not looking at the camera.

"Yeah," he says, "I'm sure it was, yep, he would be. You know, there are times when the younger photographers expect everything to be looking into camera. Strange. No, 'cos that would have been exactly what I was looking for. And you are quite right, Simon Guttmann would have been over my shoulder."

Eagar believed in Guttmann's teachings, carried them with him. "Still do." Guttmann lived to ninety-nine. "The key Simon thing was the invisibility of the photographer," says Eagar. "A photograph should be like a Cartier-Bresson moment, something you observed, not a reaction Annie Leibovitz-style between the subject and the photographer. A lot of it is fashion, I guess. Certainly these days I find myself getting the subject to stare at the camera. Because people expect it."

"Beyond cricket were you taking in," I say, "other things at that time? I'm thinking of visual arts. Paintings. I'm thinking a couple of years later was the first moon landing by humans. I'm wondering what influence, if any, these things were having on you."

"I've got a complete set of the first moon landing photographed off my TV screen."

"TV screen?"

"Live from the moon. Apollo 11. I'd just got married. It was '69, the moon landing. We married in December '68. We'd just set up in the flat in Richmond. We didn't have a television. Television wasn't that high on the priorities but that morning I went to the shop and rented one regardless. Took out a year's rental on a black-and-white TV set and stuck it in the corner and sat up all night with a large two-and-a-quarter square camera in front of the screen, oh, and maybe a 35mm as well, and occasionally went outside – because it was a clear night – to look at the moon. And I thought, 'My god, there's a man up there.'"

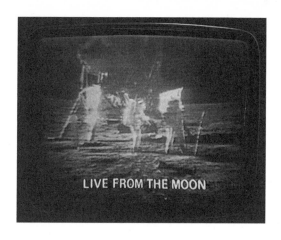

LIVE FROM THE MOON

1969 Live from Patrick Eagar's TV set. By Patrick Eagar

"Always been interested," Eagar says, "in astronomy and planets, and I devour the NASA website to this day. I always look."

Leeds was Eagar's choice of location on the first day of the World Cup in 1975. The ground was full so the gates were shut which hadn't happened here since either '48 or '56, resident old fast bowler Bill Bowes couldn't remember which. *Wisden* claimed '66. Many thousands of the people were immigrant Pakistanis from nearby towns. They had travelled by coach. Sometimes the public address system at the ground spoke Urdu. It was Pakistan playing Australia. When, in late afternoon, and dressed in a factory foreman's-type overcoat, the umpire Tom Spencer announced a wide ball by Thomson, Thomson flipped. What cannot be seen in the photograph Eagar took is this: Spencer is gummy. He

43

has no teeth, though his eyes are in good working order as for fifteen years he had been catching trains instead of driving to matches, to spare them. Meanwhile Thomson is as Thomson generally was. It is seconds ago that the ball racketed past wildly out of reach and the batsman, Wasim Raja, continues to hug his cloth-capped head with his hand.

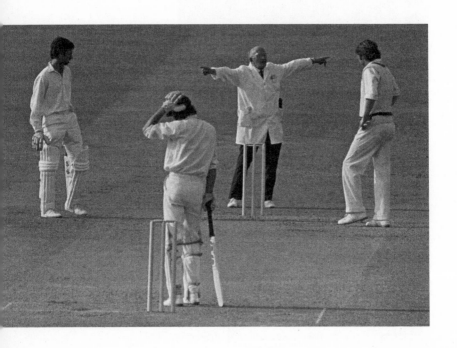

9 Umpire Spencer signals wide, Headingley, 7th June 1975

Within this little set-to Thomson is night and fright-
ening, Spencer is day, but the photograph has Spencer
signalling wide *at* Thomson who is signalling his levels
of pissed-offness *back at* Spencer. "Wide" is the most
expressive signal in any umpire's repertoire of signals.
Spencer's arms are outstretched with such gunbarrel
zeal that his index fingerbones are at risk of popping
out of their skin casings. His black-panted legs are
splayed, his hips are rocked towards Thomson, his
whole demeanour flashes impudence. This 61-year-
old – all gums, no teeth – is chewing Thomson out. They
are not merely equals, Spencer is boss, a distinction
which is backed by cricket law. The bowler *appeals*. The
one who *decides* is the umpire: stooped, ever-present,
worry burdened, mostly silent, can't miss a ball. On the
other side of the boundary fence, hunched over, seldom

speaking, hardly daring tear his eyes away, aware that the ball he skips so that he may take a leak will surely be the ball when the action explodes, is Eagar. Transfixed, lost in reverie; inside the photographer's head the umpire becomes his spiritual twin, he is *him*, except *out there*. It is pure plain thinking to think of Eagar as longing, in some residual barely real way, to be out there, this Eagar who loves the game, who relishes its intricacies and anachronisms, whose father Desmond captained Hampshire County Cricket Club then ran the club for decades as secretary, deputy-managing the 1958–59 Ashes tour to Australia when his son Patrick was fourteen, a boy at boarding school following the tour over the wireless who one day in Bournemouth got to meet Len Hutton, the Hutton on the cover of a young cricketers' yearbook his father had given him, the only time in Eagar's life he has ever felt starstruck.

Loves the game, yes – that does not explain why he made it his life's primary subject.

"I always say," he says, "I had this fascination with long lenses, you know, telescopes and long distances and what you can do."

Spencer used to bat in Kent's middle order and excelled at three other sports – football, boxing, table tennis – professionally but here he is no more a player than Eagar (at his most energetic, hungry, during these months of his career, setting up his tripod before other

photographers got there, guaranteeing for himself the best spot, his thoughtful eyes framed by square-shaped glasses, hair combed and parted tidy at the front but hanging wilder, curly, windswept at the back) who, as a pre-teens leg-spin bowler, once took 8 for 4 in a schools match despite a mislanding wrong'un and an anti-textbook action ("I used to jump twice," Eagar says, "on my right foot as I came in to land. I'd land on the back foot then do a jog forward on the back foot. I decided, at thirteen, I had better make my action more orthodox. The ball never spun the same after that").

Eagar is seventy-three now, still debonair. He plays golf ("maybe too much," he emails one week – "last week consisted of 108 holes on two Open championship courses") and though he loses his share of golf balls, that's no problem, he has a barter arrangement with the old made-of-cement opening bat Geoff Boycott (who "has an insatiable appetite for prints of his one hundredth hundred. I suppose he gives them away, signs them. I delivered another nine copies two days ago. We have a rudimentary exchange for golf balls. I lose golf balls and Geoffrey has them, so it works quite well"). The current rough exchange rate is three golf balls per photo.

When Spencer wide-called Thomson it made a change from no-balling him. Twelve was that day's no-ball

tally. Thomson was on his first big tour, fighting stir-rings of homesickness, just got married, missing the sun, swearing at the rain. "He shopped for toys for the children he hoped to have one day" – so observed journalist Adrian McGregor. His boots didn't fit his feet. They were plastertaped-up, while in the nets, a shocking habit this, one he never got around to ade-quately kicking, he'd been bowling off eighteen yards not the full twenty-two. A fortnight after Spencer/ Thomson, Eagar photographed this

10 Umpire Bird calls
no-ball, Lord's, 21st June 1975

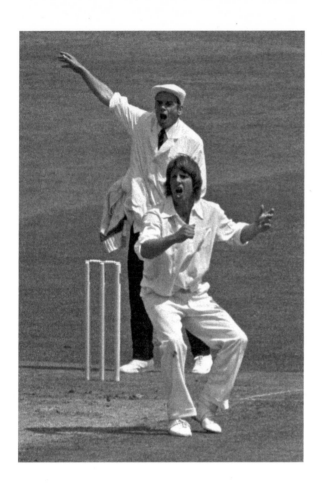

in which Dickie Bird's roaring no-ball, Thomson's wailing anguish. Both mouths are open but Bird's mouth is open wider. Bird is the taller figure. His face is more muscular. Bird's cheekbones are jutting out. And three weeks after that Eagar was back in Leeds.

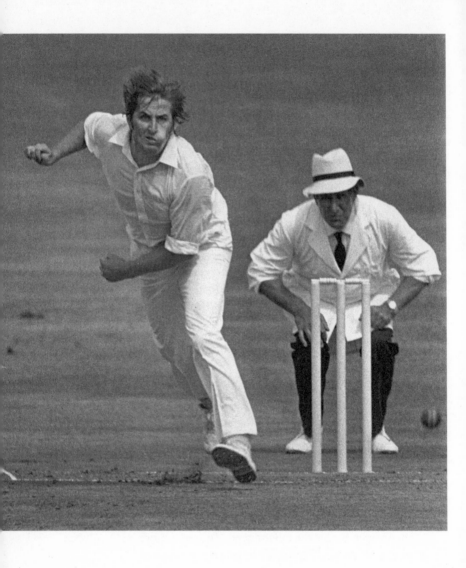

11 Umpire Fagg monitors Gilmour, Headingley, 14th August 1975

"Patrick," the cricket statistician and writer Irving Rosenwater had said to him years before, "in any cricket photograph you must include the stumps, as a reference point, both for batsmen and bowlers." There exists an Eagar picture of Garry Sobers swivel-pulling so fluidly that nearly none of the compass's 360 degrees are left uncharted. But the stumps are missing. "I feel it's an error on my part," Eagar says. The Sobers photo was taken mid-1973, using a 1973 camera, which in common with 1975 camera technology compelled a photographer to shoot tight or risk sacrificing quality. So important stuff sometimes got lopped out. Stuff like stumps.

After Rosenwater uttered it, Eagar thought about it. The longer he thought, the more Rosenwater's advice stuck. And, at the bowler's end, where there are stumps, there's an umpire.

In this sequence of three umpire photographs – if that is what they are – our eyes are swarmed. A lot is happening. Where to look is not signposted. Is it a Gilmour photo, is it a Fagg photo? Is it a Bird? (Or a plane?) In boxing the writers and the blue ruin-roused audience members have long tended to pay solid attention to the referee. Joyce Carol Oates wrote,

> So central...is the referee that the spectacle of
> two men fighting each other unsupervised in an
> elevated ring would appear hellish, obscene...
> The referee is our intermediary

and more, he is their "moral conscience", a balm to the people gazing on the bloodbath, freeing them of certain emotions – dread and guilt – that they'd prefer to not feel, guilt being a foreign country to cricket people sitting in front of their TV sets seven hours a day, five days straight, chores and household commitments be damned.

The boxing referee's role is more constant than the umpire's. Also, more crucial to a man's fate. Though not necessarily to a contest's outcome. But the cricket umpire is every bit as vital to the pageantry. Not our moral conscience – what is he? He is the closest creature to us. Often: imperfect hair, wrong build, out of shape,

out there. He counts the balls, counts bumpers, holds the jumpers and caps, oversees sightscreen adjustments, keeps at least one contorted eyeball on where a bowler's feet land, clock-watches, consults his light meter, looks to and smells the sky for signs of rain. His influence over out/not-out adjudications is shrunken, it's a stealth de-powering, yet even now before the heat sensors, dodgy predictive tracking and computer reviews kick in it is the umpire on the field who has first go at making a decision, one last non-relinquishing by the humans to the machines. The umpire stands. And he stands between the game and a kind of unspooling.

These three Eagar photographs get this, and...there's just so much to see. Stop in front of a cricket match, be slow, really strain and peer at and listen to it: no such thing as a one-track proceedings. Multiple storylines, a dozen potentially, more, untangle, Eagar cramming in as many as he can, a bit like that thrilling photographer of American streets, Garry Winogrand. Eagar is not photographing a street, on which people may walk, sit, beg or window-shop, he is photographing a live sporting scene, unfolding at speed, which by warped translation makes him Winogrand hit with a fast-forward undersway: Winodeluxe? "Against what you're saying," he says, "there was, still is, a market for the very simple photograph which a newspaper may use in any context. Take the Gary Gilmour. If you crop out the umpire, and everything else, you could say it's a picture of Gilmour bowling at Sydney Cricket Ground

or at Port of Spain in Trinidad and people would accept that" – and it's true, I've seen it exactly, the same picture with Arthur Fagg chopped out in a David Frith-edited October 1975 issue of Eagar's own *Cricketer*. Against all this, too, Eagar says photographing the umpire was only ever a "low down" priority of his (and keep in mind naturally that in the course of any conversation strung out over many months and crossing continents there'll be moments of whole truth-telling, moments of being self-deprecating, moments of – what's the word – mis-steering).

"Gilmour and Fagg is on the longest lens I had at the time."

For that to work in 1975 sunshine was needed: if he was to get close, if the detail was to still be precise, painterly, grass divots, loose sods of pitch crust, dust kicked up, studs on a sole, hair sweat-glued to a forehead. Tongue, a cheek, swollen. "I love it when the seam is upright like that," Eagar says. "It gives the bowler extra credit." The clock hands on the umpire's watch. See them almost ticking. The umpire's mind – ticking. "Arms on knees," murmurs Eagar. "And so low. It is not something you would see today at all. He's obviously looking for the no-ball and everything else at the same time. I guess the current way, where you're standing upright, watching the crease, flipping quickly to the batsman…There's a moment when you're not observing. Whereas here – was he like that all the time?"

Fagg, like Spencer, was a between-the-wars Kent batsman. Strong hooker – long arms – five Tests – rheumatic fever came at a bad time for his cricket career – said to be careworn as a batsman, guarded as a man – monosyllabic except when multiple syllables were absolutely necessary. Expecting life's currents to run against him not for him was how old teammate J.G.W. Davies put it.

"A white picket fence, with a rain cover" – unseen above the bowler and umpire's heads – "now you'd have a great big advert," Eagar says. "Which especially in colour would be contrasting, competing, ugly so maybe one was lucky in those days."

Two years later, Fagg died: on the same day as Eagar's father, who had a heart attack at fifty-nine one holiday night – September 13th, 1977.

Spencer died in 1995. Few outside northeast England, where he died in the village he was born in, noticed. He was listed as still alive in the "Births and Deaths of Past Players" register in *Wisden* until 2003.

Who ever dwelt on an umpire?

Minutes before taking the Spencer/Thomson photograph [9], Eagar took another in which the action was also occurring at Spencer's end. Looking hard it seems to be mostly inaction, a bowler has bowled, everybody waits, and the bowler's not even chiefly a bowler but a spare-parts medium pacer making up the required allotment of overs.

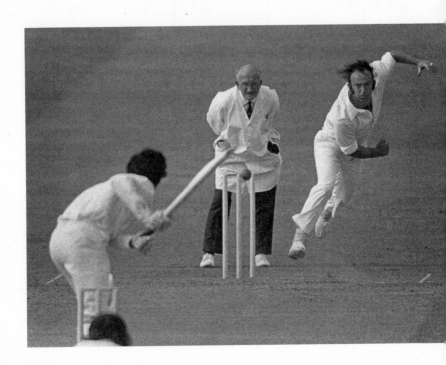

12 Doug Walters to Asif Iqbal, Headingley, 7th June 1975

Except he's Doug Walters, as photographable a cricketer as ever lit a cigarette before batting, whether in agitation or in boredom. Consider three photographs, all non-Eagars:

Walters in white thongs in Dungog on the family's antbed pitch, his mum's rutted shins like verandah posts pouring out of her spotted dress, she is wicket-keeping in front of the outdoor toilet.

Walters in a repurposed suburban football ground's dugout where photographer Viv Jenkins spied two derelict power sockets ripped out of the concrete above Walters' left earhole.

Walters on a bench, a lighted smoke between his lips, his padded legs straddling his bat, which is a Gray-Nicolls Scoop, it is facing scoop-side out.

In the last two he is not even batting. Simply waiting to bat. Three classics. No need to relook them up. Hard not to be warm towards them. Hard as well though to see past the accoutrements, or affectations, the thongs, dunny, two sockets, cigarette, Scoop. Typical Walters-style elements and they hide Walters.

A fourth classic: he is in the bath at Bath (the UK town). It's a teamshot. This time the bath (or tub) is the obtrusive thing. Each of his ten teammates (naked presumably but underwater other than one who's found a towel) has a camera-friendly smile. Walters doesn't, he has too much cool insouciance. He is not looking anywhere near the camera in any of the four photographs. Yet in all four he is hyper-alert to the camera's presence. Posing. More: cultivating – an image.

In Eagar's photograph [12] that opportunity is cut off to him. Cameras are out there but Walters knows not where. Walters is bowling, straight at Eagar's camera, and we see him: shaggy yet balding. Innocuous. Also old.

Eighteen years later Mark Ray took an unimproveable Walters photograph. Walters was in a WACA hospitality box in Perth with a wind-up telephone, a portable dual transistor/cassette player, a newspaper's form guide and a twist-turn knobbed TV for company. On the screen was a horserace. But Walters was not looking at the horses. He was staring out a giant window at the super spry playing field, where the light could

some days seem pornographically yellow bouncing off the pylons and girders and concrete walls scarred a peculiar rust colour on account of the high iron content in the city's water. And the camera seeped into him, under the skin, even though Walters was loosely awake to Ray and his camera being there, here's a fragment.

In Ray's photograph, Walters is old but safely old. He does not have to be young anymore: he has retired. Eagar photographed him old yet still playing, therefore old and vulnerable, and apart from finally *seeing* him it is hard not to feel.

The batsman is Asif Iqbal, who was the non-striker in the Spencer/Thomson photo. Walters bowled six serviceable overs, filling time before Thomson and Lillee returned.

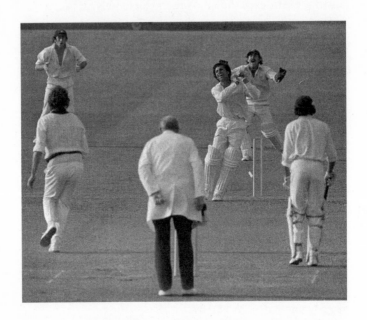

This happened.

But what? Also, what if – it were a painting, cartoon, lithograph, cave wall sketch or a canvas nailed to a church ceiling? Failed art. A batsman's stumps get rearranged into a croquet hoop, and he laughs. Only as a photograph is it believable. Sun sweeps over his face, half shaded, half lit, like a blessing. The photograph swears: this happened.

13 Dennis Lillee bowls Asif Iqbal, for 53, Headingley, 7th June 1975

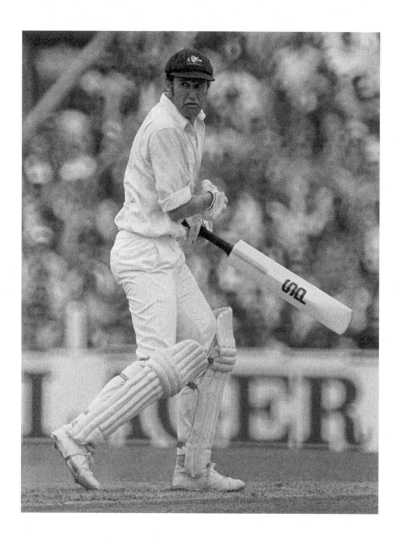

14 Ross Edwards batting at The Oval, 14th June 1975

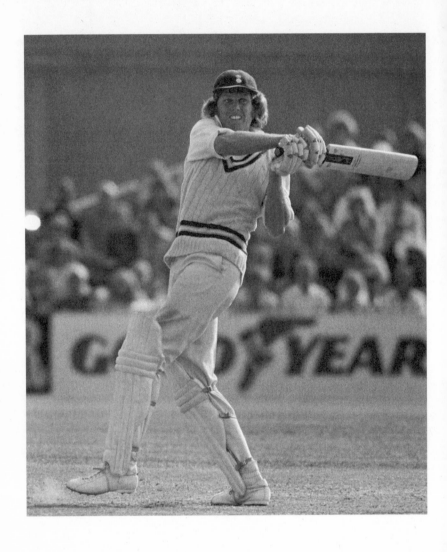

15 Barry Richards hooks, Southampton, 28th June 1975

When Eagar photographed Ross Edwards as an Andy Roberts rib-orbiter slipped through, something invisible in real time was caught on the batsman's face. Some emotion – anguish, worry or fright, roughly the emotion the watcher might fancy should be there under the circumstances but never actually sees. And here it is.

Two weeks later Barry Richards played a hook stroke and in Eagar's photograph his face seemed shadowed, teeth shiny white. The teeth are proof the stroke worked, proof of emotion, satisfaction maybe, or pleasure, bliss or joy.

Capturing of live emotion is beyond TV's powers. TV is OK at emotion in the aftermath, once a six is hit or a batsman is headed for the exit, but not during. TV is too slow and too fast. TV is too facile, panning for the next thing, the galloping-away ball, incurious about what has just been. TV highlights reels are no remedy. YouTube is cricket's friend but only its fairweather friend, a bleached wastescape of fours, roars, screamers, group hugs, flying stumps and disputed decision slo-mos, each attesting by turn to the uselessness of TV cricket highlights.

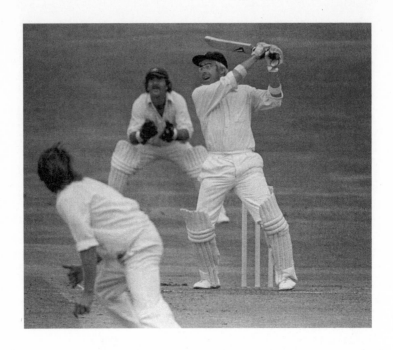

The blind "can't fake their expressions" – Diane Arbus's words, and an explanation for why she liked to photograph them – and a peeling back of something real, something felt, is happening in these four photographs too. All four batsmen can see. In the prematurely grey David Steele's case his vision is actually magnified by spectacles; they are rimless. But like the blind these four batsmen are unguarded in front of the camera. A power imbalance is at play and they are the vulnerable

16 David Steele cover-drives Thomson, Headingley, 14th August 1975

ones, emotionally naked, faking nothing. The power is Eagar's, whether he foresaw or even saw it on their faces or not.

"There was an element of discovery," Eagar says. "I don't think one ever saw it at the time. It all happens so quickly you've no idea but once you get your contact sheet, and you are looking through it for the first time, and suddenly you see faces – 'Gosh,' you go, 'that's interesting.'"

"I think you are mis-steering me, regularly, this suggesting," I say, "that these things, photographs, are happy accidents."

"That's all. And then later," says Eagar, "you can look back. That's the strength of photography. You just record what's in front of you. The other day I was reading about the woman from the famous picture in Vietnam of the girl napalmed, she's in her fifties now, going off for operations, laser surgery, to get rid of her scars and her pain, and she [Phan Thị Kim Phúc] and the photographer [Nick Ut] have kept in touch. At the time he would have just seen it and photographed it."

To quote Dorothea Lange, a quote quoted widely out there – "To know ahead of time what you're looking for means you're then only photographing your own preconceptions."

Still the quote is getting nowhere close to the wirings of the mysteries. Such as, if luck is the answer how is it Eagar corners so much of it? Why should coincidence shadow him? The sight of Iqbal, Edwards, Richards or Steele could have floated before K. Narayanachari, Bruce Postle, Ken Kelly and plenty fine photographers of 1970s cricket who could have sat behind Eagar's preferred bit of boundary fence. Pinched his latest long lens. None would have found that tremor of emotion, unseeable by watching eyes. Not that he planned it any more than Dorothea Lange, photographer of migrant pea pickers, a-buck-every-thirteenth-hour cotton hoers, processions bearing food for the dead, people with no jobs, in elegant headwear, each retaining their irreducible singularity, also their privacy, would have wished Eagar to plan it. Try plotting this: a batsman

gets bowled, down the toilet go his team's hopes, and he laughs. The mere hatching of the plan would curse the absurdity from ever eventuating.

"You say you can't plan for that but can you dream of that?"

I'm asking. I really want to know.

"If you have experience," says Eagar, "you realise if you're at a certain angle down the wicket – and maybe the Asif Iqbal one was a bit that way – you are going to see the batsman's face whereas if you go to cover or square leg, square leg especially, you'll go for overs without seeing the guy's face at all."

One thing I do know is the less that's known – about a batsman's score, the state of a match – connected with these four photographs of emotion the richer they are as photographs, the wilder the possibilities.

Turns out Ross Edwards – anguish? – retired from cricket at the end of that tour to provide for his family. For four years he'd been letting his accountant's job slide and relying on a cricket-only pay packet while believing the next batsman dropped would likely be him.

Edwards, when I send him the photograph, says he has never seen it before and has no memories of the ball, none of the match, in spite of other recollections of that bowler, Roberts, and times facing Roberts being clear in his mind. "On one occasion when trying to save a Super Test, a forlorn hope, I was intent upon leaving every ball possible, however Andy," he says, "still got the ball up off a length and got it to jag back and in doing so hit me three, four or five times on my right shoulder, a most unusual occurrence." The right shoulder, tucked out of sight out of range, was supposed to be Edwards's safe shoulder. Times facing Roberts, he observes, were unpleasant experiences. Roberts disliked batsmen. Judging from the photograph, the ball pitched short and he, failing to get in line with it, must have snicked it then spun round automatically to see what happened but beyond that there's little he can add, he says.

Among several framed photographs on Eagar's walls is David Gower hovering midair while twisting his goldilocked head out of the road of a Malcolm Marshall bumper. The zooming ball misses Gower by inches. Gower has signed the picture – "One of those moments it's more comfortable to be at your end of the lens than mine" and definitely at some odd moments Eagar was conscious of his advantage, aware of the power he held over the unguarded batsman who is oblivious to Eagar's presence, unable to control his expression, blinded.

"I sometimes wondered if any batsmen were aware enough. Let's think of," says Eagar, "an extreme situation" – when a photographer's choice of seat may pre-empt or trigger eerily a batsman's downfall…

"Say Australia are batting like at Lord's last year and they've made five hundred and whatever and the photographers are all moving squarish to square leg, extra cover, cover. Not remotely expecting a wicket. You are looking for the cover drive. Looking for the cut. Or if the batsman's left-handed or if it's up the other end you are looking for the hook or a firm stroke through midwicket. Then the innings ends. It's England's turn. To watch a load of photographers move again, to a position down the wicket, in line with the stumps, the significance of that is enormous. You are looking for bowled, lbw, caught behind, caught at first slip. It is a statement of intent a photographer has over a batsman. I often wondered if any batsman saw me move. There were times I felt guilty moving. I'd be thinking god hope he doesn't see me, you know? They wouldn't. They *wouldn't*. But the message was there: I don't think you are going to make many runs. I think you are about to get out."

Maybe a highly psychically attuned cricketer – maybe Mike Brearley – might notice a photographer move. "Well, exactly. One did wonder. As you say, Brearley might have. Or Atherton. Atherton might have."

With power came stresses. "As a photographer you are a journalist, it's a position of record, if something happens it happens and your job is to take the photo but you also have a second stage. The edit. In a war situation the correct thing is to not edit on the hoof. Which I'm guilty of. I missed stuff thinking I won't take that. What you should do is take it then either edit it or allow somebody else to edit it. I think that's the rule. And trust your editor. Equally, I always regarded cricket as the basis of my existence and would go out of my way not to humiliate anybody unnecessarily. There's the extreme, which is a horrible book" – a 542-page rare melding of sanctimony and boofheadedness – "that someone" –

Paul Barry was the author – "produced on Shane Warne, publishing photographs of Warne in the most unpleasant surroundings, one of him looking like a yobbo, with a cigarette and everything, there's a borderline there which I wouldn't cross. Though that's not really on the field. Have I ever suppressed anything? Probably not. Hm."

The sign at the back [15] says Goodyear, a make of car tyre, but for Barry Richards every year since 1970 brought frustration. His first Test match was that year. So was his fourth and last Test. South Africa's race policies and exile left him playing out the rest of his career in the backblocks. Adelaide. Southampton and surrounding towns. Kingsmead in Durban along the Old Fort Road. Richards was too good for the backblocks. So, in part, he played his cricket inside, for the outside. One afternoon while batting he gave vivid and literal illustration of this parallel way of being. In his head he imagined the field a clockface. Going clockwise he then stroked all six balls of one over to a (they say) different sector of the fence.

He wished the outside world might see. TV cover-age was scant and reached only the outside few. "But one county game always televised was the forty-over Sunday game and I can't prove this but I'm pretty certain," says Eagar, "that when it was a televised game Barry would almost always do well" – and Eagar's right. Richards played eleven consecutive seasons for Hampshire. On Sundays, he averaged 54.56 in John Player League matches televised on BBC2 and 37.04 in games within the same competition that were not on TV.

Hampshire, Eagar's father's county, was the team Eagar followed and often photographed. Regularly opening the county's batting with Richards of apartheid-era Natal was Gordon Greenidge of Barbados. "Hellbent on outdoing each other. Mayhem. They both could be moody but they relished problems," thinks Eagar, "and in about '73 perhaps Barry batted against Bishan Bedi, who was at his best, on the last day on a turning wicket when Hampshire and Bedi's team, Northamptonshire, were first and second in the championship."

For two tense hours Hampshire stalked a target as people crammed close on the wooden benches so

that they may see. Ninety to win. Richards in the first innings had succumbed to Bedi, stumped. To ensure no repeat he did not put a boot out of his crease, just kept pushing forward, with wrists, his balance exquisite, so observed John Woodcock. Eagar used to read Woodcock's *Times* reports next morning and consider his job well done if he had photographed everything Woodcock described.

Richards finished 37 not out, the game was won. "Came off drenched in sweat," remembers Eagar. "My father said he thought that was the best innings Barry ever played for Hampshire."

Another occasion, in Basingstoke, he fell for 56 and Glamorgan's third-man fielder remarked to the spectators behind, "Now we can start dealing with mortals."

Another time – televised – he hit Lancashire for 129 and Eagar photographed him "two paces towards square leg, bashing through the covers. He was one of the first

to absolutely take the mickey out of bowlers. It was a Muhammad Ali approach to batting."

The Ali likeness extended to his swagger, grace, confidence and disdain for chump opponents, to the butterfly and the sting. To his smile.

"That was quite a feature," thinks Eagar, "of his batting. The teeth bit."

It happened – but what? Or, is this *what* what it seems? Roland Barthes believed

> as soon as it is a matter of being – and no longer
> of a thing – the photograph's evidence has an
> entirely different stake. Seeing a bottle, an iris
> stalk, a chicken, a palace photographed involves
> only reality. But a body, a face…the *air* of a face
> is unanalysable

which, if true, means Barry Richards's teeth are not flashing positivity. What looks like thrill, fretfulness and laughter on the faces of Steele, Edwards and Iqbal ain't.

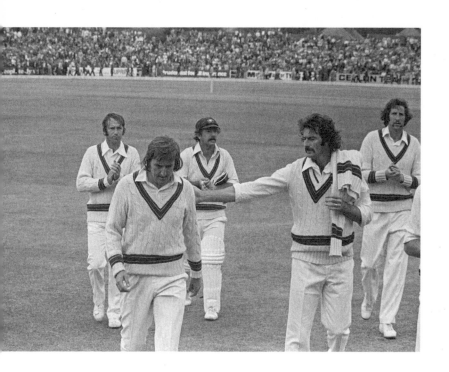

The black cloud on which these men are trailing off Headingley's green field is the emotion least expected. A glumness that in real time was not only beyond seeing. Beyond envisaging. They've shot out England for 93. It's a World Cup semi-final. The flat-haired, crumple-trousered, unsporty-looking one at the front, Gilmour, has been bowling the biggest benders of his

17 Innings break: the Australians walk off Headingley, 18th June 1975

life. Six wickets for 14 are his prize. Out of picture is the captain, Ian Chappell, leader of a flamboyant team, thought to be a content and united team, a team filled with men who would excrete blood and rocks for that team. This tour was Chappell's last and began in non-cricket country, Canada, with some rehearsal one-dayers and a look at Niagara Falls. There a pile of American teenagers buttonholed the team, asking where they lived.

"Australia," replied opening bat Rick McCosker.

"Is that around here somewhere?"

Which underlined how, in cricket, even the biggest somebody is a nobody in 185 nations of the world, and, staring into the cascading waters of the falls, maybe there was something they were supposed to be seeing, a message, or reminder: of humility; "humble" wasn't ever used to describe this Chappell-led team, the word that stuck was "ugly", which was multipurpose, a sum-ming-up in one breath of the team's beercentric ways, cultural narrowness, win-whatever-the-fuck-it-takes ethos, perceived swearing, perceived sledging and personal abuse of opponents, and a certain perceived ungratefulness for their lot and good fortune in life.

The men themselves did not accept ugly. Yet nearly everybody seemingly in cricket was calling them ugly. And at such times it may have felt like they were eleven against the world.

This Eagar picture is a spyhole to an alternate reality, suggesting within the team was wariness, grievance, silences, bad blood spatters. Walker, at far right, is fixing or appears to be fixing a filthy mistrustful glare on Lillee. On Lillee or Gilmour. Or maybe that is overanalysing Barthes's "unanalysable": a big word, a blanket word; or it could be faces in a photograph are sometimes exactly what they seem, sometimes not at all what they seem, and the trick and the hitch is not knowing which is which, or when, and this is part or a lot of the intrigue of photographs.

The team's wicketkeeper Rod Marsh, third from left and peering cranky out to mid-distance in the photograph, said in a 2015 oration in London: "I will never understand how personal abuse can make the situation any better…Supposedly I said to Ian Botham on his arrival at the crease during a Test match *how's your wife and my kids?*…I can promise you I would never ever."

And in a 1991 memoir Viv Richards reflected on his first trip, 1975–76, to Australia: "Until then I had believed, however naively, that Test cricket was the ultimate sport of gentlemen. The Australians smashed that… A kind of nastiness…Force of their hostility…As soon as we wandered out on that field, we had to face their taunts. It did not prove easy to concentrate when someone was snarling at you and saying, 'You fuck off, you black bastard.'"

Though more recently, about the time Marsh was delivering orally and formally, Viv had without explanation (slipshod '91 ghostwriter?) scaled that memory back to: "Sure, they would say the odd thing, but it wasn't racial. No. Just the normal Aussie bravado."

And staring again at the photograph. Staring and trying to glimpse their hearts, men who even now it is not clear what they were and who shrink away, even now, from uglinesses people claim that they spun. Or just a photograph. Trick of the light. Beating on them, beating them out of original shape, like an anvil.*

Eagar took the photograph and the day after, June 19th, Evonne Goolagong (third child of eight of a Wiradjuri sheepshearer) married Roger Cawley (an English metalbroker) and two weeks later beat Margaret Court ("The nun who taught me in sixth grade considered me a dreadful tomboy") in a Wimbledon semi-final. Seventy-five: hard telling what was what, in Australia especially, where the government's overthrow got rubberstamped by a Queen from England. Goolagong thrashed Court and with her racquet "painted pictures in the sun" said the *Times*. Compared to the cricketers the tennis players seemed genteel, like Lipton types not beer people, though anyone who knows Gordon Forbes's classic *A Handful of Summers* knows the Oz tennis pack too were attendees of the hello bastard school of chivalry:

* Thanks to D. McComb for the steal.

"Hello, bastard," he said, although I hadn't seen him [Rocket Laver] since Hamburg

Or, as the Australian players succinctly put it, they got everything "arse end up"

"Bloody pissed off" as the Australians say

Says Eagar, "Where I was positioned was close to the players' dressing room. They were walking off towards me. Not looking excited. But public displays of emotion – this business of celebrating a dismissal – weren't that common then."

Barry Richards and his teeth were captured during a tour game between Hampshire and the Australians at which Eagar also photographed Greg and Ian Chappell walking off. Or walking on. "Southampton. I knew the ground well," Eagar says, "because I was brought up there, almost. Photographers and the public were allowed on the field. You only had to clear off once the umpires were out there and the fast bowler was steaming at the end of his run-up."

Gate takings for the match hit nearly £5,500 in three days. "The problem, really, was eliminating spectators."

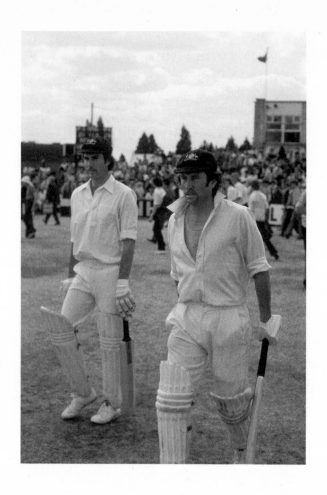

18 Chappell brothers in Southampton, 30th June 1975

One is buttoned up and the other is unbuttoned down past his breastbone.

Greg could be methodical, princely, balletic, force-field-like when he was focused, fragile stamina-wise, toothcomb-like in his recollection of facts, facts that were sometimes jaggedly at odds with others' remembered versions of the same facts, a bit aloof, sexy, stern, craving alone time, a fan of Cat Stevens songs. Ian, five years older, did not seem like he was like any of those things.

"Background's a bit messy," notes Eagar. A steeple would be a nice touch. Steeple and a chapel. "Should have been a bit further to the left. But I'd have been in Ian's way."

They are walking on, in fact. It is after the lunch-break on day two. Greg is twenty minutes away from watching Ian run himself out trying for a second run. Freakish how often that'd happen; in one notorious stuff-up in hometown Adelaide, Ian claimed to have nearly finished running *three* to Greg's one.

"Two brothers on the same team is unusual enough," says Eagar, "for me to work quite hard to get them together."

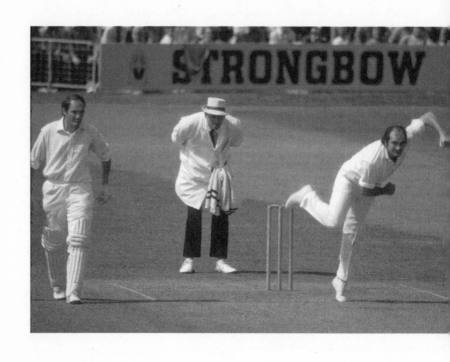

1974 Taylor twins, Derek and Mike,
Somerset v. Hampshire in Taunton. By Patrick Eagar

1994 Waugh twins meet Bedser twins. By Mark Ray

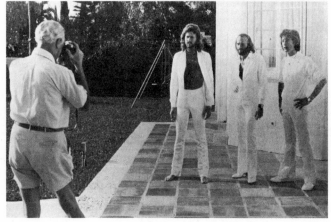

1954 Lost dropshotting stylists, Edda and Ilse Buding of Germany,
from tennis's pre-powered-millionairess days, photographer unknown

c.1977 Gibb brothers Barry, Maurice, Robin of the Bee Gees,
in Miami, three degrees of unbuttonedness

Mark Ray met Eric and Alec Bedser in Sydney in the first week of 1994 and again three weeks later at Adelaide Oval. He said he wanted to photograph them with Test cricket's first twin brothers. Keen on the idea, they sat down for him at day's end, and Ray disappeared, after a while Ray returned, and one by one Steve then Mark Waugh sauntered in. Ray neither touched Mark's top button nor asked him to do his collar up so high. Ray did not plan for or painstakingly adjust Eric's weathered, giant left hand. Only the seating/standing order was deliberate, and the location, which was a small room near the home team's dressing room with cinema-style old leather chairs and an open-air view of the playing field, no windows, nothing to filter the evening light. "For years in our various houses I had a framed poster," says Ray, "of the Diane Arbus photograph of twins" – the identical twin Wade sisters from New Jersey. "And then," he says, "in 1991 my wife and I had identical twin girls."

One wearing a cap, the other (three others) uncapped.

Had the Chappells had on helmets not caps Eagar's photograph [18] would have been a piece of nothing. But the cricket helmet was two years away from being invented. Helmets seal off expression, emotion. When the helmet's presence turned to ever-presence Eagar

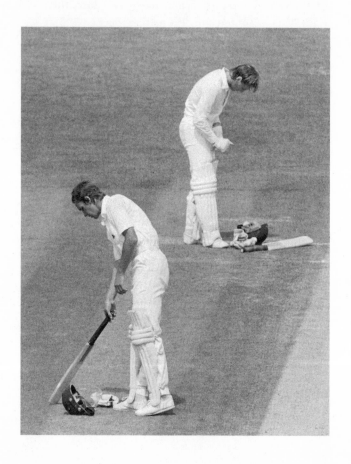

1983 De-helmeted (Tavaré & Fowler). By Patrick Eagar

felt it like a blow. "Great thing about caps was nobody seemed to have the same-shaped cap. They were all a little different. You could identify a player from the back." Sighing he goes, "Helmets – you just accepted it, and you can see the reasons and I guess it's wise to wear a helmet although when they first came in and Roberts and Holding were in their pomp I remember asking what happens in your Shell Shield back home? Do people get hurt? Do they get hit? And they said no, because if you are not wearing a helmet and you are batting you make sure your head gets out of the way. Being hit on the head was rare. You were more likely to be hurt fielding at short leg than batting. I remember batting, not that I ever played at a level, and getting hit once, on a rotten wicket, and I at least knew the ball

was going to be coming at me whereas if you're at short leg and something comes out of the blue…"

Spring a.m. Email inbox: Eagar's first cricket photo. Taken at Southampton. "Taken near the same place as the two Chappells picture on a box camera. My first camera." Eagar was thirteen and allowed like the others to roam free on the outfield during intervals. The others, curious boys and young men, are dressed for the cold in pants too baggy for their legs. Stepping out on the left, bespectacled Bruce Pairaudeau would never outdo the 163 he made on this day but the coincidence of Pairaudeau's highest score and Eagar's first day with a camera at a cricket field is unconnected, as the email lands, to the feeling I'm feeling…

1957 West Indies v. Hampshire in
Southampton. By Patrick Eagar (aged 13)

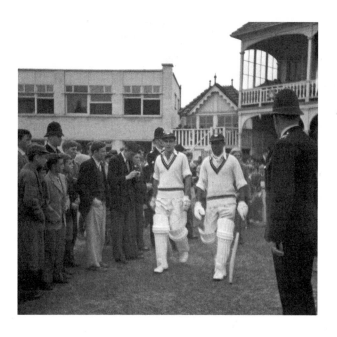

Everton Weekes, on the right – more used and worn by time than I am used to seeing him. That face: it has seen some seaports, some places. Gloves that are shiny, bulging, they do not belong on his fingers.

But the neckerchief is the same.

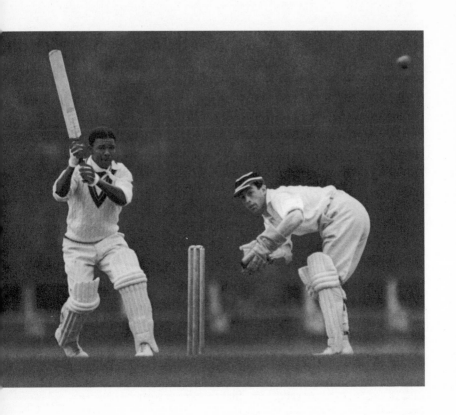

1950 West Indies v. Cambridge University at Fenner's. By Willie Vanderson

Weekes – since the first day I saw it, days when this photograph has not fleetingly rinsed my subconscious have been rare. This effect is triggered by no other cricket photograph. No other photograph. It is something about Weekes. Some sincerity of aggression together with softness. It was cold when this photograph was taken too; the day before, eight West Indian bowlers bowled and none took his sweater off. Next day Weekes square-cut balls into the pickets too fast for the third-man fielder to move, something P.B.H. May, playing for Cambridge, had never before seen. Few in the crowd would ever have seen a black man. In Nottingham a stranger, an old woman, came up and rubbed Clyde Walcott's hand like it was coconut husk and a syrupy white might seep out. Weekes hit 304 not out in the innings depicted in this photograph, and it took me years after first seeing it to realise it was taken on the same day that Weekes hectored himself, in a monologue, which was overheard* by the wicket-keeper, name Denman, who's also pictured.

Said Weekes (to self) on entering the 290s: "C'mon Weekes man, play careful in the nineties, careful, man."

* Thanks to F. Keating – "Summer of the Spinning Tots" – for the story.

Still more years passed before another awareness sank in that the photographer who photographed it – Willie Vanderson of Fox Photos – was the same photographer who took a more frightening photograph of Frank Tyson on the follow-through. Vanderson made Tyson's upflung left arm look like an exclamation mark appended to a lightning bolt. Don Bradman used to dig that Tyson image out for visitors at slide nights on Holden Street. Bradman reckoned it the "finest picture of a fast bowler I've ever seen…you couldn't possibly generate more power from the human form".

About Vanderson I know not much other than in fifty-seven years on Fleet Street he was the zoo guy. Not a born animal devotee. Simply, one quiet news day he was dispatched to the zoo, where a zookeeper squirted a hippo with a hose for Vanderson's benefit. After that the animal gigs kept coming. And Tyson in the Vanderson photo is like an animal in the wild as much as a member of the human fast bowling species.

About wicketkeeper Denman I know less, his *Wisden* obit runs to two sentences, and the second sentence is all over in eleven syllables:

He managed only four runs in five innings.

Slender wire, it's fraying, links these two Weekes photographs, Vanderson's to Eagar's. The ground at Southampton, known as Northlands Road, was turned to tarmac, it's honeyed brick and blocks of houses now and a sign was not long ago sighted there:

No Ball Games.

One day as an older boy Eagar went to Bond Street, London, looking for long lenses. In Cambridge where he was studying no shop had what he was seeking. Long telephoto lenses did not exist in Cambridge. Somebody at the university had got hold of a box and on one end of the box had stuck an aerial reconnaissance lens, possibly German, probably from World War II, possibly from the war before that war. This contraption took roll film, it was a sort of small-scale prototype of a professional cricket camera, and it produced 3×2-inch negatives. Restricting it was, hence this Bond Street trip. By the time the shopkeeper wrapped the long lens in a box and secured the box in a cardboard bag it was still morning, in midsummer, a Monday, 1963 was the year, and on leaving the camera shop Eagar caught the tube to St John's Wood station and from there walked with the latecomers to Lord's.

Inside the ground a tense Test is a little over three-fifths gone in its slow-fast unfolding. Frank Worrell's West Indians are on top. Five wickets flake away, in a flash. Down is up, and now it is England needing only 234 to win or with rainclouds scudding, the light intermittently dim, to last eleven and a half hours to draw.

But down go Edrich, Stewart. Thirteen minutes pass without Dexter facing a ball. Down goes Dexter. Three for 31 and the crowd sit *in stunned silence*. So records the poet Alan Ross. *Unwilling to believe it*. V.S. Naipaul overhears a West Indian say to an Englishman on a bench outside the Tavern *the only man who could save all-you is Graveney. And all-you ain't even pick him*. Eagar is in the Warner Stand, down the back, bad angle. A Rover ticket from his father got him into the ground. Within his eyeline are signs, NO CAMERAS ALLOWED, and in one pocket of his anorak are sandwiches, in the other pocket is a 35mm camera, one of two that he owns.

Still in its box, in the bag, is the new long lens.

Barrington and Cowdrey are batting.

Hall is on. The crowd's quiet has broken. A young commentator in his first season of calling the cricket on TV listens to *fifteen thousand West Indians yell themselves hoarse*. The commentator is Richie Benaud. When Hall turns to bowl the pavilion is behind, the vast windows of the Long Room forming a wall of grey that mixes with the overhanging dullness to hide the ball's flight-path. Hall is built like a ship's flagpole, his shirt billows as he sprints, he's aiming at a particular zone, a ridge. Hall is thirsty for the ball to rear up out of that ridge at Cowdrey's chest, fingers, neck or head. Two men stand hipside and two others, like a reflection in a lake, are on the off side. So Cowdrey has, apart from ducking under the ball, choices. He may hook and risk one of the four men catching him. He may try to jab down and risk one of the four men catching him. He may let the ball strike him, which eliminates one danger, increases other dangers. Just once Cowdrey seems trapped between the second and third options. This ball, the blow, to Cowdrey's left ulna, a snapping sound, the rest is silence, a hurt man's bat banging noiselessly on the ground as he walks off, forlorn, these are the first pictures Eagar takes at a Test match.

The degree at Cambridge was a bonus. Photography was where his zest went. Sometimes his photographs for *Varsity*, the university paper, appeared near Germaine Greer articles.

"Did I meet her? No. See her? I remember her coming into the paper one day, quite scary, probably I kept my head down. She was older, a graduate."

A life photographing cricket would mean a life in which half the human race were most of the time cut off to him as subjects.

"At the beginning I took quite a lot of pictures of women, either for the fun of it, or as part of something, a couple of good-looking women I used to photograph quite regularly. I liked that. It was a time when one was trying everything. Did you want to be Cartier-Bresson? Did you want to be Zoë Dominic, who did theatre work? And certainly you went through the David Bailey syndrome where you just took nice pictures of nice girls and they got published and that was great."

He photographed The Beatles. Photographing theatre was enjoyable. After a while it felt less enjoyable, faintly artificial, there would be a set, a producer, actors, lighting people, and him, "you were very much only a looker-on", like in cricket, unlike cricket. Actors are not unguarded. Actors are acting. When sport stars say who's writing this script they are being sardonic and rhetorical. Whereas in theatre there is an actual script. Everybody knows what is going to happen next and Eagar would photograph the thing that happened next the best he could. Even photographing women, models, he sees that "Irving Penn, Richard Avedon, *Vogue*-type photographers, they were a bit different, but I'm sure once you got a studio set up and you got, say, Jean Shrimpton and you were all in the right frame of mind you couldn't fail to get some quite good stuff." He says this now. At the time he did not know what he wanted to photograph. He could imagine happiness photographing various possible genres. In the room next to his at Cambridge was a 1st XI cricketer, Mike Griffith, whose father Billy was a high-up administrator, secretary of Marylebone Cricket Club no less. Mike had a visitor, there were names above the doors at Cambridge, and the visitor saw the name Eagar. He knocked.

"Hello, my name's Swanton. You must be Desmond's son."

The conversation did not drag. Swanton asked Eagar what he was up to, what he wished to be up to. Get into photography, Eagar answered.

"Oh, well, I help run a magazine. You better come along and do some work for us."

Swanton's first name was Jim, his magazine was the *Cricketer*. Eagar's first photographs ran in the *Cricketer* of June 4th, 1965. *Sports Illustrated*'s June 7th issue decorated newsstands that same week, different continent, ignoring cricket as usual and leading with Muhammad Ali's knockdown of Sonny Liston in Lewiston, Maine. The bout lasted 132 seconds. Neil Leifer wasted none of them, snapping one-two-three epic photographs, in flaming Ektachrome, one with a fisheye from above showing Liston felled on a canvas coloured yellow like Mandurah estuary sand, another a strobe-lit panorama from fifteen rows back taken shortly before the knockout, and this one

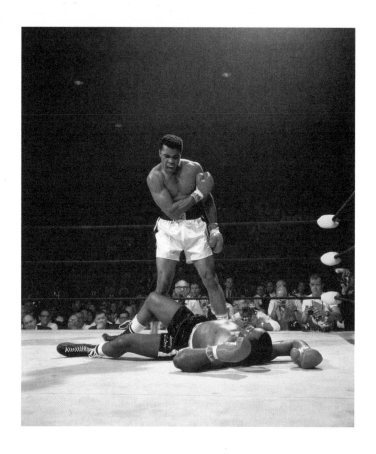

on page fifty-two. Page fifty-two was what *Sports
Illustrated*'s editors thought it deserved at the time. It
does things to photographs, time. In this photograph
are certain qualities, familiarities (yet how?), there's
the capture of live emotion as Ali roars *get up and fight,
sucker* for he knew the punch he'd thrown was not
hard. See as well the wide and graceful framing, it's a

1965 Ali v. Liston. By Neil Leifer

perfect stage, smoky blackness above, the importance of supposedly unimportant figures, these being the ringside watchers and photographers, also the angle of Liston's right shin…parallel to Steve Waugh's right thigh in this book, page 15.

Couldn't arrange it any better.

With your fingers.

If they were little men you were manipulating.

Leifer, the young *Sports Illustrated* photographer, said later

> if I were directing a movie and I could tell Ali where to knock him down and Sonny where to fall, they're exactly where I would put them.

Long after its page fifty-two unveiling the picture was acclaimed greatest sports photograph of the twentieth century. The timing, same week as Eagar's first week in the *Cricketer*, may be one of that century's stranger sports photography coincidences.

"There are only coincidences."

Henri Cartier-Bresson said that.

Leifer was twenty-two, Eagar twenty-one. In a page four photograph in Eagar's first issue the Trinidadian wicketkeeper Deryck Murray on-drives Titmus at Fenner's. Beside a brick wall, under a tree taller than three sightscreens, walks a woman. Her dress rides above the knee. Walking at her are two men. Between the woman and the men are three more men. One

stares at the woman, one is observing the action in the middle, the other is craning and twisting away from the cricket and the woman to look at something happening out of shot, some other narrative, threatening any second to walk into this photograph. It begins. Uncertainty, poetry, they are together in an Eagar photograph for the first time.

The English summer of '65 was unseasonally sleet-heavy. Eagar's first good portrait was of his neighbour Griffith, the fellow boarder who'd inadvertently jolted his life's bearings. Griffith's pictured reading, cramming, during a break in play, white-clothed. At New Field in late June he photographed Winchester's captain R.J. Priestley, school-blazered and dashing, albeit looking at the camera, as Eagar was yet to encounter Guttmann. Some pranks he never repeated but were worth trying once, a view over first slip's shoulder taken from between two wooden spokes of some horse-pulled farming artefact in Canterbury, maybe it was an antique roller. In Worcester he crossed the Severn, climbed the cathedral stairs, to photograph the field and the town's flat surrounds through a teardrop-shaped window fragment. Scarborough in July was the scene of his first alarming action pictures, Fred Trueman near the point of maximum elongation like some rubberband-man rare breed and, on one foot, Brian Close clubbing a six off his bat's flipside over the wicketkeeper's head.

In August when the South Africans visited Eagar borrowed a friend's £100 Russian-built mirror lens and crept up on Peter Pollock in Southampton. Six stumps in the background, an umpire, the batsman, tapping, and Pollock's swivelling at the top of his long run, the left hand clutches his right sleeve, which is rolled up, he is pensive, thinking about that last ball, did the batsman go forward, go back, if back should he pitch further up, and what of the batsman, where's his strength lie, on-side, off. This was Pollock's thought process. Walking back was for him never dead time.

The Headingley Test was a slice of history. Photographing Tests was the preserve of the photo agencies. But Swanton did some special negotiating. Going to the ground on the second morning Eagar detoured to buy a converter to make his lens twice as long. Soon after getting there he witnessed Edrich clunking Yuile, a left-arm New Zealand spinner, for six causing umpire Charlie Elliott to duck and Eagar got it all, the non-striker Barrington's fixation with the soaring-off ball, wicket-keeper Ward's worry for Umpire Elliott, there's a lot to look at. Already the umpire was a central character. It was Eagar's first summer. Swanton's next available column drew his *Cricketer* audience's notice to Eagar's work during that Headingley Test while making mention of the usually "not at all high" standard of English cricket photographs.

Or "he made sure I got in there" is how Eagar's memory goes "then ruined it by publishing an editorial along the lines of *Patrick's photos are much better than the agencies.* The agencies took umbrage and stopped me coming in."

Sports photography's frontiers were widening. Eagar's secret first Test pictures down the back of the Warner Stand, quietly prising his new long lens from its cardboard fortress, were taken fifty-three days after Richard Avedon took the teenaged Lew Alcindor's photograph where 61st Street meets Amsterdam Avenue in New York. Boy basketballer Alcindor became Kareem Abdul-Jabbar. Avedon's portrait was part glamour shot, part head X-ray. For Eagar the stage stayed small. He and his cameras were kept out of Test ovals until 1972. The summer after '65 he took striking portraits of the player-commentator Benaud, squeezing a pen like it's an orange that he'd like to spin from leg to off, and of Sussex's heartthrob aristocrat captain the Nawab of Pataudi. Once the toss took place in Eastbourne and the nawab was waylaid in Paris. Eagar's Pataudi picture lit up the *Cricketer* cover of August 12th, 1966. That month Guttmann sent Eagar to Vietnam.

"Couldn't be two more different people on this planet," Eagar speculates, "than Simon and Swanton. Simon was extreme left-wing, an immigrant, bright, I suppose humble in a way. Swanton was extreme right-wing. Bright and kind in his own way but pompous, anyone would say that. Wouldn't travel in the same car as his own chauffeur was, I think, one of the stupid remarks once made about him. In common they had this ability to encourage young people, get them started in their careers. Swanton gave you work, pushed you in various directions. It's a great ability and I admire people who do it. It's important. Swanton had to approve of you first, and he had his own level there, I don't think he had any sensitivity to the less privileged of this world in the way Simon did. Simon probably saw cricket as a rather outrageous upper-class activity, people in white clothes running around being very English, but I don't remember him opposing me. I fitted in somewhere between the two of them, and moving both ways, still do. I have a great sympathy for the underdog. I take the *Guardian* every day and I do find the *Telegraph* very annoying."

After Vietnam, after Guttmann, "I stopped for a bit, totally.

"And I worked for *Which?*. Running tests. It was a lot of fun." The elbows-and-knees blankets simulator substituted cut-open tennis balls for elbows. "A natural lifespan at the magazine was three to four years and I worked there for two years maybe. I mean, you didn't do the work yourself, you commissioned someone to do it, testing washing machines or nylon stockings and the most noteworthy thing for me, as I was intrigued by the subject, and I have since developed a long interest in the subject, is I was given red wine to test, I went round and hired all the top wine people in England, wine specialists, journalists, tasters, the head of Christie's, their faces were quite a sight when they had to taste this stuff because it was about 1968 and, my god, the wine was cheap and the wine was awful."

And from time to time all through the second half of the '60s he'd catch a glimpse of a *Sports Illustrated* from America, right up to the early '70s even, until finally he got a subscription and wouldn't miss an issue.

The English summer of 1975: occasional rain. No sleet.
Cricket looked how cricket looked, forever, a red ball,
white clothes, no helmets hiding faces, all games played
within daylight hours. Things would change in two,
three years but Eagar was here now.

19 Hot afternoon at Trent Bridge, 11th June 1975

His photograph of kids watching feels like the last seconds before the fading world and the world that's coming collide. Round two of the World Cup. The World Cup was three rounds then semi-finals and a final with each round's matches occurring on the same day. So Eagar had to pick: Trent Bridge in Nottingham on a Wednesday. England hosting New Zealand.

There is a new scoreboard. The previous Trent Bridge scoreboard was in the old antipodean tradition that still thrives in Adelaide, a wall of wood with twenty-two players' names carved into it, plus their scores or figures, with the names sometimes painted the colour of the team's cap and information supplied about how-outs, catchers' identities, wides and byes etc., who fielded the last ball, the umpires, every wheel and panel of the edifice hand-operated. This new abridged scoreboard gives essential data only, it's semi-automatic, and behind it, also new, is a nine-storey council office building designed by an architect whom Robin Hood missed out putting an arrow through. Eagar took nine pictures, for posterity, of the spruced backdrop, some of them close-ups, some landscapes. His camera lacked a fast motor drive so this took him nine balls to accomplish. His left hand twitched ready to push a button tripping a remote camera in case of a dramatic spill of cricket action.

Also visible are ads for Ladbrokes and CHS Publicity but little else that's clutter. There's a further ad, for Cup sponsors Prudential Assurance, but it is on the grass and covered by kids in hats or hatless some with shirts peeled off sitting beside the boundary's edge, not being shooed or pinned down by rules, no no setting foot on the grass, no no touching players with fingers. Later in the day an outswing bowler, Peter Lever, bowled a troubling few balls at Barry Hadlee, not dismissing Hadlee, but bothering Hadlee, and when the over was done Lever returned to his long-leg fielding post where an admirer shook his hand.

In the photograph a bareheaded batsman hits the ball on the leg side. Batsman's name, *Old* –

Chris Old.

"Photographing a view of a ground you've got to do it just after the bowler has bowled when the action," Eagar says, "is going on because if you wait till between balls you get fielders with hands in pockets, they're walking around, they're putting in another bit of chewing gum. It looks sloppy."

Twelfth man for England was John Snow, not happy about not playing, ropeable actually. That is there if you are looking for it in a picture Eagar took: so is melancholy: an aloneness:

20 John Snow on the dressing-room balcony, Trent Bridge, 11th June 1975

Snow is a poet, he was writing and publishing poems even in his playing days. "He was definitely," Eagar remembers, "pissed off and in a state of undress, which was not so fashionable or legitimate as today when we're used to players coming out in their vests. Covered in tattoos as well. The sunhat: I think that was to convey a slightly disrespectful air. It wasn't a particularly clever photo. Anybody who was there would have got it. It wasn't a sheepish, instant protest. He was out there a while. I think, as well, he knew he was being photographed."

About the time when Eagar was photographing the scoreboard and building he

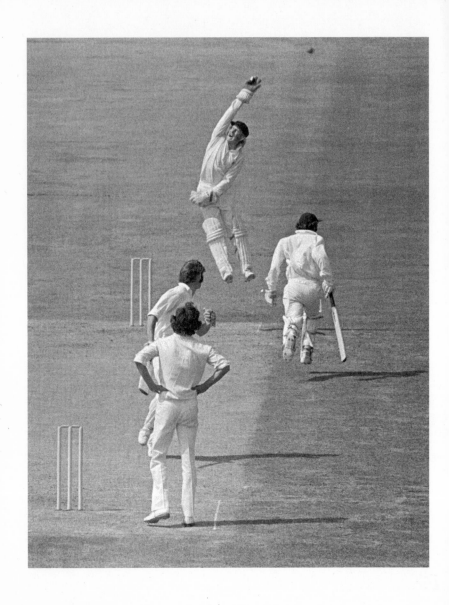

21 Wild throw evades Ken Wadsworth, Trent Bridge, 11th June 1975

photographed Ken Wadsworth leaping. This was on
the second, remote camera. Wadsworth was dead from
cancer fifteen months later. Glints of sunlight splash
on his closed eyes. Ball's beyond reaching, which we
know, he doesn't yet, however high he jumps his jump-
ing is futile, both ball and photograph are a pre-glint: of
what was to come. See Wadsworth's shadow, thinner
than the others' three shadows – a sliver, a trapdoor.
Breyten Breytenbach, the Afrikaans poet, told writer
Lawrence Weschler of his mornings in a to-die cell in
Pretoria Central Prison

> the hanging room…was the central
> characteristic of the place. Even though you
> never saw the room, you could hear it – you
> could hear the trapdoor opening. It would
> send a sort of shuddering through the entire
> building.

Wadsworth's death, in the photograph, makes no
sound. Maybe it is seeable, or not.

But a sort of shuddering: that's there.

Knowing what we know happened to Wadsworth changes the photograph. But the same applies to all photographs always. And it is not as if we can unknow any of it. Taken remote control on a camera set up for a horizontal the Wadsworth photograph could be judged accidental. Wadsworth's vertical leap has been cropped in the editing and while the original horizontal contains no players beyond these four messing the scene, there is an expanse of vacant grass visible to the right, there is an unused pitch on the left.

No photograph is entirely not an accident. Eagar sensed a near run-out so pressed the button. Arranging his cameras beforehand he'd done so aware a vertical could be sliced out of a horizontal but the reverse was far unlikelier. Not that the process or thinking mattered. Power of prediction – of premonition of death –

does not lie in the taking of a photo, and it is not a power a photographer has. It is in the photo. To suppose photography is too lowdown an artform to be capable of such sorcery would be naivety most highblown. Aboriginal Australians understand this, and in a courtroom on Arnhem Land's edge I heard a mighty orator and

Gumatj leader, Galarrwuy Yunupingu, say a freelance photographer, a weddings guy, who took photographs of an Aboriginal man and two children on land traditionally theirs near where a yacht club now stands was guilty of killing their spirit, desecrating their spirit.

Spirit captured on a camera's film was out of a person's own control.

Next in that courtroom, this happened. The lawyer, stepping on clan secrecies, asked about Yunupingu's late father, to which Yunupingu croaked "he trained me", before his body slumped, his head hit the bench, a doctor entered the witness box, the witness could not keep consciousness, he was hospitalised, the case was adjourned till morning.

Ken Kelly, a wartime decoder, cipherman and famous English cricket photographer, once for "no remote rhyme nor reason" photographed an umpire leaving the field for a rainbreak. Kelly snapped; the umpire stepped off the turf, into the pavilion, then to the toilet, and dropped dead. Syd Buller was that umpire. Buller had tanned or burnt forearms, because he always rolled his sleeves to his elbows, a serious man, but wry, his hair permanently parted down the middle, he didn't waver

in his judgements, didn't shirk no-balling chuckers, didn't shoot the breeze with players. Before umpiring he'd been a wicketkeeper. He was the same way then. "Never seen you look so well and relaxed," a co-umpire said to Buller and two weeks later on the third afternoon in the fourth innings of Warwickshire playing Nottinghamshire he died. In the freak photograph he is in conversation with Nottinghamshire's Dave Halfyard, it is unclear who talks, who listens. Dennis Amiss and Garry Sobers walk a couple of paces behind. "What *can have been the instinct*," Ken Kelly wondered, "that inspired me to take the shot?"

Tiny Hugo Yarnold had been Buller's wicketkeeping understudy at Worcestershire. The keeping gloves were like meat trays on Yarnold's hands and he had a special affinity with leg-spinner Roly Jenkins who'd speak to the ball, "Spin for Roly", before bowling it. Yarnold not only succeeded Buller as wicketkeeper. He followed him, despite the loss of both kneecaps, into umpiring, where part of the job description is to stand. Many times Buller and Yarnold stood together, two stern judges of chuckers, and four years and six days after Buller's death, Yarnold, at the end of the third and last afternoon of Northamptonshire playing Essex, got in his car, collided with an eight-wheel lorry, and died.

The date was August 13th, 1974: no play possible. Rain all day. Yarnold may as well have not gone to the ground. But that is not how cricket works.

In Buller's case, he died and the rain cleared and the game resumed without him, Warwickshire chasing a target and getting the required runs with fourteen balls to spare, a new umpire, Umpire Oakman, standing in Buller's stead, that's how peripheral a figure the umpire can be.

Both wicketkeepers; both umpires: the photographer's ever-crouched, always-watching proxies...

The following cricketers were photographed by Eagar and dead before thirty-five: Wadsworth, Barrett, Slack, Folley, Kelleher, Kersey, Bosch, Saxelby, Cronje, B. Hollioake, Masimula, U. Rashid, L. Williams, M. Islam, Morton, P. Hughes. Before fifty: Stead, T. Nicholson, Milburn, Faber, I. Ali, Clift, D. Bairstow, Lamba, S. Clarke, M. Marshall, Carrick, N. Malik, D. Davis, N. Williams, Hookes.

1979 Rainbreak. Papua New Guinea v. Argentina at Banbury. By Patrick Eagar

Eagar says: "Wadsworth was probably the first one, and in a way he's one I remember more because it seemed so wrong but then you got used to life being not good."

A funeral in Melbourne, early 1980s – Helen Garner has no memory of this but others there who weren't writers do, of her pushing past people to the grave's edge and taking notes as a succession of men, each waiting for the man before him to finish, scooped dirt on the coffin. The ritual rocked Garner. It was a Jewish funeral. A cricketer's funeral may be as jolting. Players are all in black. It is the players having to arrange their bottoms on a hard wooden bench this once. Any photographers in attendance, with cameras on their person, but cameras not in plain view, are aware of having photographed all these players in the past. With some they trapped the detail they had sensed, other players stayed elusive. One in particular's being slowly lowered – for the photographer at a cricketer's funeral, what *can have been the instinct?*

Ken Kelly "never, if I'm being critical, quite got the mental attitude to 35mm to maximise its potential," Eagar thinks. "He was using it like a 5 × 4 plate camera.

He had his own little built-in box at Edgbaston. Had it built especially for him. Which was great, except he wouldn't necessarily let people share it and it meant nearly everything he took was from above, looking down the wicket, same angle." In war days Kelly was once on a Sicilian escarpment and "oh my god I saw the Germans set fire" – Kelly told journalist Frank Keating – "to the cornfield where our boys had taken cover then pick them off one by one as they ran from the conflagration."

"At Edgbaston," Eagar says, "at the Test every year Ken kind of made sure he was indicating that he was in charge. One thing he was in charge of was the lunches that the sponsors supplied. And he used to make a big deal of giving them out to the photographers. He had a lovely wife and smashing daughters and I've had good relationships with most of the other photographers but Ken, no. Have I talked about Ted Blackbrow?

"Ted worked for the *Daily Mail*. Started when he left school as a messenger for one of the big photo agencies who'd give him a penny for his bus fare from the agency office to Waterloo station to pick up the plate film being sent from Southampton, where they had photographers aboard the *Queen Elizabeth* and *Queen*

Mary. And because Ted was about fourteen, and he was quite fit, and he liked running, he often kept the penny and ran instead. Did this with the plates one day. Got a bit tired on his way back from Waterloo going over one of the bridges. So he put the plates on the parapet of the bridge. And they fell in the Thames.

"He got to the office. Said the plates hadn't turned up. Or he'd have lost his job.

"And sitting on laptops, like we are now, you can send pictures instantly to anywhere. Before I came along the cricket photographers in England were all agency guys really, Central Press or Sport & General, and the main man for Central Press was Dennis Oulds. O-U-L-D-S. Who was lovely and, do you know, I knew him for years and never noticed, even though we must have often shook hands, that either his forefinger or his thumb was missing. He'd lost it."

Lost it in an engineering factory accident as an engineering factory apprentice. "And I always remember thinking the handshake didn't feel quite right but it took me ages to work out why. I liked Dennis a lot. He was really good news. He talked about the old days, talked about the equipment. The thing was, you did all tend to get on because you knew the problems of photographing cricket. You knew when things went wrong why."

Oulds was dapper, kindly eyed and he used his black and unwieldy 48-inch Long Tom pre-roll plate camera to the end, to retirement, though the Long Tom's day had gone. It looked like an aboveground submarine. Carrying it to the carpark afterwards was a job for four shoulders.

"I did go," Eagar says, "and interview Dennis once – oh twenty years ago, probably." Twenty-six years actually in Oulds's home, Oulds's wife Peggy interrupting on the cassette tape to nail down whether Eagar would be staying on for a meal.

> DO: "I went in at Central Press as a – what's the term? Type of apprentice? My father paid a small sum of money? An *articled pupil*. That's the law term. First six months I started on no pay at all. After six months I was paid ten shillings a week."

> PE: "And what was the first time you went to a cricket ground?"

> DO: "In 1934, as a messenger, to The Oval."

> PE: "How did you get there?"

DO: "Well I went with the photographers, George Frankland, Jimmy Sime. Wally Lockyear was the other one. These fellows were gods, you know. Not as they are today. They really were people of stature. Especially Jimmy Sime. Men with cameras were heroes."

PE: "What, in a car?"

DO: "No! Didn't have cars in those days. Had to go in a taxi because we had to take all the big stuff, the equipment. But I didn't use the big cameras, the cricket cameras. My job was still going around photographing the crowd. People waiting, people drinking. People doing all sorts of things. Players coming out. Players going in. See, the papers used to use all this stuff."

PE: "Because, I suppose, there was no television."

DO: "There were three London evening papers. The *Evening News*, the *Star*, the *Standard*. Sometimes, covering a Test, Central Press would have as many as sixty or seventy photographs published a day between those three. It used to change with editions. If a wicket went, out'd go one picture, in came another, and if there was ever a day when you only got thirty-odd in the evening papers: *Oh, hell, not a very good day today.*"

And a soft sadness that's in his voice cannot be completely pressed down when Eagar says now, "I guess the whole photographic business has been in decline since I started."

Round three, the last round, of the 1975 World Cup rolled up and Eagar drove the short distance from home to The Oval for West Indies against Australia. He photographed rear-view Thomson [2], Kallicharran hooking [4] and strain [14] preying on Edwards. At team training beforehand he revisited Walters as a subject. The thing this time versus the other times [12 etc.] is it's unclear if Walters is looking at the camera, or not, awake or oblivious to Eagar's presence, whether he's entertaining calculations and envisaging how, in the final photograph, he'll turn out, as himself perhaps, it's a hope hard to quell and worth hanging on to, or as the stranger he usually sees in photographs taken of him. It is not certain if he is feeling grouchy. Hungover. Or intrigued but pretty zen about being photographed, or intruded on. There is just a sunblasted ambiguity. A half-guardedness. And maybe this time the right conclusion to reach is: it's him.

22 Doug Walters at training, The Oval, 13th June 1975

Also the light's fantastic. "Light and lighting is so important and at The Oval in the morning," Eagar says, "the light always came in that direction. So at net practice if I got to one end I'd get this backlit effect. I think it was because of a load of white seats reflecting sunlight into the players' faces. And I wouldn't say I overdid it but I certainly did it a lot. For years."

One autumn midmorning the week before flying to Laos on holiday, when a fog hung over his green garden with its controlled pockets of wildness and he was needing to get off Skype to cook – "For eight of us, the neighbours, that's retirement for you" – our conversation started with writers he had collaborated with and drifted as far as Neville Cardus. "I met Cardus twice. Photographed him twice." Twice and seven years apart, in Embankment Gardens beneath the National Liberal Club and later, degrees warmer, at Cardus's flat near Baker Street. "I don't think he was terribly interested in photographers or photography. The one I didn't photograph and really, really, really regret was C.L.R. James, who I got close to fixing an appointment with in the '60s, he was living in London, and I just never did, that was a mistake."

In 1975 Eagar's photographs were running weekly in the *Sunday Times*, monthly in the *Cricketer*, and ten times annually in a magazine started by a boy who subscribed to the *Cricketer* and thought Australia deserved a *Cricketer*: *Cricketer* he called it. Sixteen was how old the boy, Beecher, was when he and two schoolmates looked up PUBLISHERS in the Yellow Pages and began ringing. They got one nope then Australian Consolidated Press – Frank Packer's magazine stable – said yes. *Australian Cricket* was the first magazine. Then *Cricketer*. Aeons before that aged fourteen Eric Beecher founded and edited, from a room in a friend's house, *Sea Scout*.

"Dear old Peter" – McFarline, another Australian – "he was a pal. Kind, intelligent, sort of high speed, here there everywhere," says Eagar. "Had a slight almost self-destruct part of him but he taught me how to fillet." That happened one night in 1977 when the travelling Australian press ate at the Eagars'. "We thought: we can't give them steak. What don't they have in Australia? So, and these were the days before Atlantic salmon was farmed in Tasmania, we went to a fishmonger and ordered a great salmon, a lovely fish, then we played golf beforehand, had a few drinks, the salmon arrived, I got my knife and fork out, about to plunge them in, and Peter said 'stop, stop, you trying to ruin that thing?' And he took me through the stages.

Of filleting a salmon." Attack from the top, cut along backbone, strive for bonelessness tailbitwise and upper quarter, flip, repeat. "I've never forgotten them."

Here is a memory Eagar has of the writer, poet, broadcaster who he loved and was loved by –

"Late getting to Headingley, luckily it was raining, and as I drove in I listened to the BBC radio commentary. Which was of nothing. Because it was raining. It was John Arlott on his own describing the covers and the groundsmen. For a quarter of an hour I listened to one man talking about nothing and it was compelling."

Passages of nothingness: time of maximum Arlott zing.

Arlott did not believe in nothingness. Not at cricket matches. Say a gull cried. That could signal an imminent weather shift – it's "strictly relevant".

When Eagar was planning a book, *An Eye for Cricket*, and desiring some short writings to go with his photographs he approached Arlott who replied: "As long as you are there while I write every word." Which was how Eagar in 1979 spent "the whole of that winter going down to John's house in Alresford and standing over his shoulder while he typed out the sentences on the typewriter, either that or correcting them longhand then his second wife Valerie would type them out for real. Then lunch." Round the typewriter, which

Arlott manhandled in two-fingered spurts, was a maze of paper, history books, six *Wisdens*, two of the *Wisdens* flung open and creasing at their spines, and a cardboard Ilford box of photo prints. "Being winter," Eagar says, "lunch was soup, to which John would add quantities of sherry and if he got the champagne bottle some of that would also find its way into the soup, with bread, cheese, pâté. Then I'd drive home."

Later Eagar collaborated on eight end-of-season photo-books with Alan Ross, whose telegram-sized character sketches and wedges of pithy match reportage strung photograph to photograph. Ross once wrote, in a poem, of Gower, the batsman hanging hovering on Eagar's wall:

> Arm confined below shoulder level
> As if winged, the slight
> Lopsided air of a seabird
> Caught in an oilslick.

Arlott once said, over the airwaves, of Gower:

> Looking almost frail with a half-sleeve shirt
> clinging closely to a not very substantial
> physique. He passes Boycott, who's got his
> helmet under his arm, like a knight at arms
> alone and palely loitering.

Between a writer's looks and a writer's writing style exists a "detectable relationship", Ross believed. Ross himself had a cultured wildness and usually a goatee, a rough and uninterested look that makes women desire to run yet get nearer. He wrote tough sentences, but lyrical. Pinpoint evocations of cricketers' swoops and glides melted into close-ups of the brothels of Tunis and Perth. As a teenager his favourite cricketer was Sussex amateur H.T. Bartlett who'd chainsmoke agitatedly till batting then stroke balls into treetops. And Ross's writing style was like that a bit too. "Quite awe-inspiring" to work with recalls Eagar, who especially admired Ross's tourbook *Through the Caribbean* which had cricket in it but also "Haiti, voodoo, all that". Their friendly working relationship happened mostly on the phone. Occasionally over lunch at Eagar's. Once Ross turned up seeking a vodka and tonic and Eagar had neither the latter nor former. "I'd dig out the pictures for a particular Test. And he'd say 'where's that moment?' or 'haven't you got something of this?' and I'd go away and report back 'no, missed it' or 'what a good idea, here it is'." Different to the Arlott relationship.

Every September 20th or so the English cricket season ends and the grape harvest begins in France. So to France they'd go, usually separately, Eagar to shoot the harvest and the 2,000-bottles-opened-a-year man

Arlott to write about it. Back in Alresford he liked to host. Clasping supersize Czechoslovakian wine glasses around the Arlott oak table would be local farmers, the village bookshop owner, doctors, poets, cricketers, cricketing identities, miscellaneous old friends, wine types and Jack who ran the railways in the south, which all points to something old England captain Tony Lewis mentioned at Arlott's memorial service – "He was saying," says Eagar, "nobody knew John completely. I knew John a bit through cricket, a lot through wine.

"And he would have anniversaries, shall we say parties? Every year for dozens of things. I got invited to a few. One was the Alresford annual fair – coconut shies, merry-go-rounds – when he'd have a golf day, eighteen holes, nine holes in the morning, lunch, nine in the afternoon and you all went back to his place where Valerie cooked venison, the same every year. The thing about the golf was he had a special book. And he did the handicaps. He'd write down the handicaps in the book. If you were doing well by lunchtime he took extra attentive care of your wine and I remember doing well one lunchtime. Then on the tenth tee I performed three air shots. Fifteen, twenty people would go every year for that. Another one was Christmas Eve when you all went off for bacon, eggs and claret at a Winchester hotel, told jokes afterwards, and the winning joketeller got a prize, and the prize was a Victorian chamberpot

until one year someone lost the chamberpot. Another was Jack Hobbs's birthday lunch. Attended, again, by a group who overlapped slightly but were all slightly different. This was Tony Lewis's point: no one knew John completely. I mean, John did repeat himself. But rarely. Talked about his times with Dylan Thomas" – Arlott used to produce some wireless poetry stints Thomas did – "for example. How they went drinking together in London. How Thomas would run out of money. Arlott would lend him some. Wouldn't necessarily get it back. The same old stuff. His son Tim Arlott wrote the most fantastic book, very human, it captured his father absolutely, and I remember one lovely line to do with some herbal mixture John was taking, something like *If two were good twenty were better*. That was John. Taking tenfold doses of everything. And he was obsessed by draught, wind and cold."

Four times, three times with friends, Eagar and Arlott went wine inspecting together: in Bordeaux, Alsace, Beaujolais…

"John loved the Beaujolais as he'd heard there were a group of people there," says Eagar, "called the Quatorzième, which is French for fourteenth, because they drank fourteen litres of Beaujolais a day. What he liked most was that to do that they'd have had to drink three litres before breakfast. That appealed to John's sense of humour in an extraordinary way. But – bless."

When entertaining cricketers, Arlott watched and evaluated. Were they enjoying the wine? Or just slopping it back?

Then: "Patrick, go down to the cellar and get a bottle of X" except sometimes Arlott let Eagar choose – "i.e. I had to assess," says Eagar, "who the people were and whether he was looking for a good, a very good, or an ordinary bottle."

Dining with Mike Brearley and about five others two nights before Brearley's first Test as England's captain they "opened a bottle of Krug 1929. John owned two bottles. The conversation that night was about, not quite tactics, but the psychology of cricket, its history." Anytime ties were required, Arlott's tie was black, because his first son Jimmy died in a road smash in 1965, leaving him, in Arlott's own words

> a lesser and a reduced person, because you
> know a piece has come out of your heart, and
> that boy, I – I don't just miss, but you see, you
> never…People say, "He gets over it." You don't.

Summer 1981 was the date of Eagar and Alan Ross's first collaboration so Ross lost out on writing the sketch of Marsh's catch to dismiss Greig. Greig who was always so coolly unfrazzled about being photographed but with that trademark proviso – "But be quick"

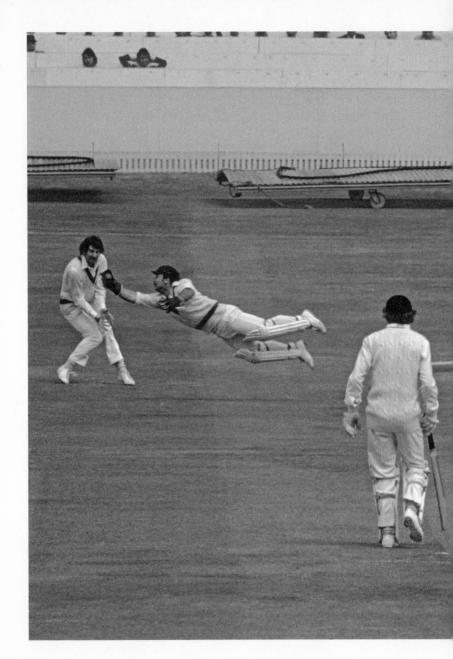

23 Edge, dive, screamer at Headingley, 18th June 1975

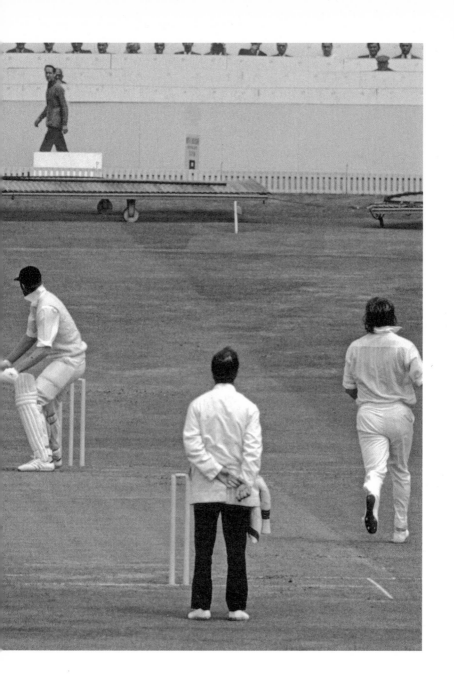

– and Eagar had to be this time. The setting is the shambolic, by England's definition, World Cup semi-final. Ninety-three out, dusted, done for. Greig in his new St Peter mitten gloves is the third to crumble. Eagar took the photograph ninety-five minutes before the mysterious teamshot departure shot [17] on page 75. It is one of the classic wicketkeeping catches. One of the all-time knockout sports action photographs although the way Eagar tells it, being positioned where he was, with a panoramic view not unlike the bowler's or first slip fielder's, all he had to do was react with the same quickness they would react. "How old was I then? Early thirties? Quick enough."

There existed, still does, a tiny delay, shutter lag, between the pressing of the button and the rising of the mirror in the camera to take the picture. So a photographer has to hit early. Similar to how slips or wicketkeeper, before a ball grazes the blade's edge, sense a kind of shimmer and start pre-twitching.

When Marsh plucked the catch Eagar was shooting simultaneously loose in colour and closer up in black-and-white. The black-and-whites were his priority. Closer. So a batsman's hit or him being hit or getting out lbw or bowled could be blown up provided the available shonky phototechnology permitted blowing up. Whereas loose stayed loose. The way Eagar edited he'd chuck out any failed coloureds. Black-and-whites including the duds got stored conveniently and forever

on rolls of film. He holds a contact sheet – one roll – up to his laptop screen to show me. Places it gently back down. "Thirty-six pictures," he says, "of which I marked up three as good. If they were colour I'd have thrown thirty-three away." He returns to his sheet. Peers at one of the thirty-three flops. Holds it up until sheet and screen are virtually touching. Says: "Recognise it?" Edge, dive…Marsh's shoes. The same moment – failed photograph – eerie.

Also, something strange: until Greig's appearance Eagar was not using two cameras, two lenses, he was shooting black-and-white only, that's how near a scrape it was to no catch, no moment, no madrigal. No photograph.

Why the abrupt shift to black-and-white *and colour*? Was it that sun sliced through clouds, brightness being a must in 1975 for colour photography, which Eagar liked to do if he justifiably could, though it was dearer, ate up processing time, was a drag changing angles because instead of moving one camera and one camera's paraphernalia he had to move two…publications mostly wanted black-and-white anyway. Was it because Tony Greig was the England team pin-up?

Eagar cannot remember, isn't sure, and twenty-three days later took, sort of *eerie* again,

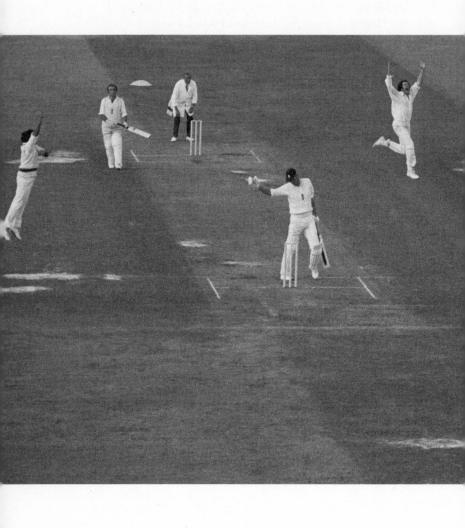

24 Greig: c Marsh b Walker 8, 11th July 1975

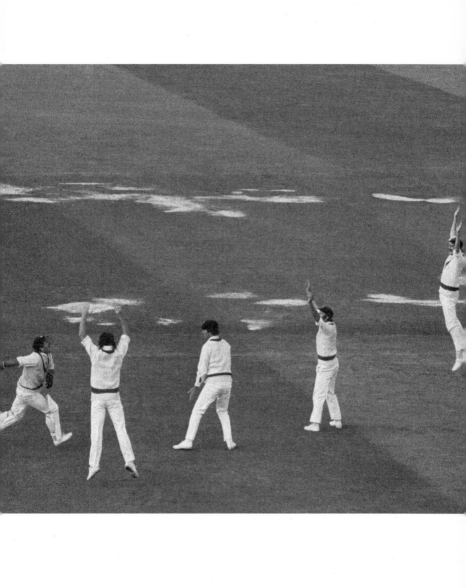

sort of a sequel: the aftermath version, Australia rejoicing, reverse angle.

This time it is a regulation Marsh catch.

Max Walker, not Gilmour, is the bowler.

Colourless. Colour's absence heightens everything, implies drama, pathos in the sawdust piles. Greig is a man broken. Eight out of fourteen Australian feet are off the ground. Colour, overspilling, in the first Marsh photograph [23] makes a dream out of the scene, like in Walker Evans's late-period Polaroids, some 2,650 of them taken between September 1973 and November 1974. Geoff Dyer has written of this last flurry by Evans: "Walls became insubstantial. The sky became as turquoise as de Chirico's" – Eagar's Kodachrome green is closer to Claude Monet's *Water Lilies* (1919),

with a cricket pitch where a light-reflecting pond should be, but not without some lurid de Chiricesque vibrations: an electric-blue anorak; first slip's coral-pink hands. (Eagar once asked that first slipper, Ian Chappell, if the catch Marsh grabbed should actually have been his own and Chappell confirmed in one sentence with two swear words in it that, why yes, it fucking should.) Six months later Eagar turned a West Indian slip cordon into five kites fluttering over the Atlantic.

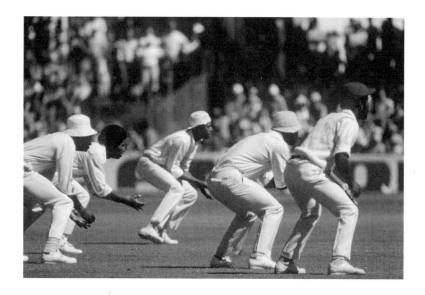

Walker Evans died on April 10th, the week before the 1975 cricket season's scheduled beginning.

1975–76 Lloyd, Julien, Gibbs, Greenidge, Rowe by Patrick Eagar

On April 10th Eagar was prepping for a Middlesex county club photocall.

The World Cup final pitted Australia v. West Indies. Nowhere but England could have produced the glitter it emitted, the tenth Australian wicket toppling at quarter to nine at night with only pale sun for light. "Anywhere else in the world wouldn't have that much daylight," says Eagar. Something between five and six hundred photographs he took. "Three hundred in a day I used to think was excessive." This was no ordinary day. And "my attitude was, almost, money's no object." The previous night's tobacco fug and beer hung heavy on the eyelids of Walters in the gully in the morning's third over when Fredericks hooked then slipped and Eagar snapped six times, six frames.

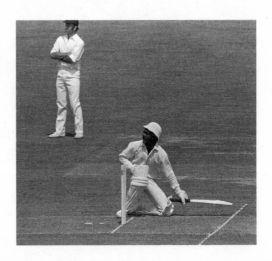

25 Six, no, out. Lord's. 21st June 1975

By the fifth frame the ball is over the fence and still flying. Six. Six runs about to be subtracted because Fredericks in the slippage has kicked off both bails. Out. Out trumps six especially a six worth zero yet Walters is still watching the sailing-away ball. Easily explained, he'd (patently) diverted his gaze sometime between the first and second frames when the bails came off and though Fredericks is out Walters does not know. Except improbably Fredericks too is watching the ball. And he had to know. Whether Eagar knew is 50-50. The view through the camera's viewfinder was not all that clear. But in Fredericks's case the bails are next to his feet. Also the bails made a noise dislodging and another (softer) noise landing. Fredericks had to have known?

Assume yes; what seems to be going on is a windchange where he's out! or I'm out! and who'll win? fade from mattering. A fielder and a batsman are revelling in the glory of the stroke, a ball's steepling flightpath. Naive times no. No time in sport was that naive. It is an optical puzzle. The photograph is about a moment that can never be seen even if Eagar had, in the modern digital way, photographed seventy-eight frames not six.

It is the moment, unphotographable, when conscious awareness is overtaking subconscious. For now, in this photograph, Fredericks's subconscious is boss.

Somewhere inside he knows he is out.

Deep down he KNOWS he cannot be out.

West Indies got over that early hiccup. They totalled 291 in the allotted sixty overs thanks to a 102 of silk and boom from their captain Clive Lloyd of Guyana. Some of Eagar's six hundred-odd photographs that day were crowd shots. Crowd shots never really had been his strong point despite an afternoon in March 1973 when he shrugged off warnings from Barbadians that Trinidadians should be avoided and may steal his cameras. Queens Park Oval with its olive hills, its low clouds, was too postcard-sultry not to attempt some photographs with people in them. He walked into the nearby public stand.

"Hey you," came a voice, "— you man."

"Me? No, no. No."

"C'mere and sit down. Have a glass." A meaty palm pressed on Eagar a fistful of hefty-smelling rum topped with a sliver for a layer of Coca-Cola. "There. Right now, tell me about this John Snow" – the oh in Snow sounded posh when the man said it – "Can e bowl?"

A rich time's chatting was had with the man with the lilting inquisitiveness. Until Eagar apologised, "I am terribly sorry, I'm going off to take some pictures," and away he went.

Got about ten yards.

"Heyyy. You. You man. Come sit'ere. Av a glass."

For an hour and a half and a bottle of rum between two he was waylaid. It is a lovely memory to hold onto now…

At Lord's 291 felt big but not beyond chasing and Australia launched gamely. One for 81 off twenty. Ian Chappell steered a ball in front of Viv Richards who as a boy at an Antiguan boys' school used to throw stones at, and break the skeletons of, lizards. Richards was fielding at midwicket. Eagar was initially positioned behind square leg but had since moved, as the sun moved, even though moving was a bother because eleven to thirteen other photographers, he estimates, were working that day. His new perch was straighter. He was up high in the pavilion. The spot has been razed. It is a members' bar now. But Eagar was there, high, alone, holding two cameras with which he was shooting in black-and-white and – not that the light was brilliant – colour.

Ian Chappell hesitated. Non-striker Alan Turner agreed on a run. Turner was slow to get galloping; his soles seemed greased with stagepaint. Swiftly he accelerated towards the end furthest from Eagar who had to adjust and refocus on the fly. Sprinting in was Viv. Still skinny as the Boy Lizard Killer, no chub or muscle on him, and wearing one white wristband, he issued an underarm flick fast enough for the ball's lacquer to have scalded his fingertips while Eagar tried to erect in midair a canvas of such width he could fit everything that was happening in. Trained on the far-end stumps, Eagar had a 1000mm long lens. Too close, so spontaneously he activated by remote control a third camera with a shorter 400mm lens that he'd stationed well below where he was sitting and slightly to his left on a bridge between the pavilion and Q Stand, Q Stand having since been renamed the Allen Stand.

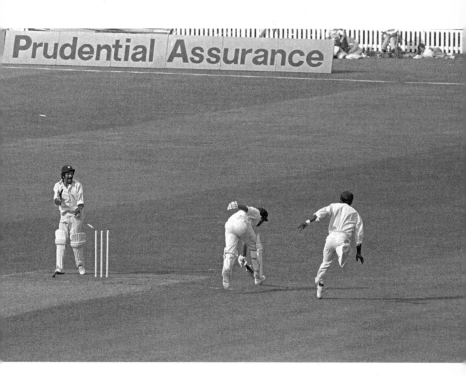

The photograph gives the impression Turner made it safely past the creaseline. Turner had the same impression and handed, on departure, his handkerchief to the umpire so the umpire may wipe the vapour from his specs. Umpire Spencer was the umpire. For the remote-camera concept, a technology little tried by

26 The art of the run-out #1. 20.1 overs. Lord's, 21st June 1975

photographers outside the US, spurring Eagar to fashion his own homespun version, this was the moment of perfect execution that made the daydreaming, trouble-shooting and getting to the ground early worthwhile.

Twenty-four minutes later Ian Chappell dabbed towards the point region and hesitated: again. Ian's brother Greg roared a sober schoolmasterly NOOOO with so many decibels they clanged in every ear present from the wings of the outfield to the tips of the pavilion. Then the third-man fielder missed the ball on the pickup. So the run was back on. Another sorry P.S. to the Chappell family run-outs saga was about to be averted. There was no predicting Boy Lizard Killer, who since Turner's run-out had moved to cover, could speed up, stop, bend, fetch, pivot and mow down a bail with a two-bounce throw – too fast for Eagar to guess too, though his chances from high were better than down low where a photographer can get blocked, players' legs can merge into blurs. That's old-school logical. Photographers now wish to be low and close and immediate but Eagar knew that by switching high he opened up the possibility of shots he could not otherwise get and, in fact, at this juncture, his main worry was "which end the run-out was going to be.

"The good news for me," Eagar says, "was it was the batsman's end – i.e. the wicketkeeper's there, Deryck

Murray's there, so the camera's prefocused on the stumps. Not only prefocused. *Pointing at* the stumps. And because I'd got the remote on the other end I was covered, both ends, so long as I didn't panic and start trying to move the cameras around and, I suppose, given one's way of working and frame of mind at that time there was no reason to panic although I might, if I couldn't work out what the hell was happening in that split second, press the button on both cameras on both ends in which case there would be one wasted frame on the film."

Which connects to another anxiety that was dogging him – "How much film was left in the camera? It's not like today where you can go on forever. You'd be counting as you went along. A roll of film holds thirty-six. You get to thirty: do you pick a moment to rewind and change it? Or do you run it for one more over because you're still thinking, even though it is a World Cup final, about economy, a little bit, and you really don't want to waste those six frames, but you're also thinking what if I get left behind and stranded without film?"

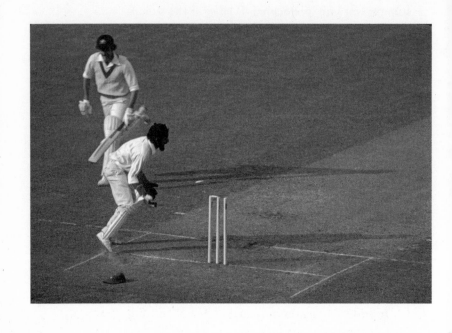

27 The art of the run-out #2. 27.1 overs. Lord's, 21st June 1975

The result: a kick-up of dust beside Murray's boot. Cap overboard, trodden-on grape. Pair of shadows destined to intersect too late. Three strip-shadows for stumps. Carefully lawnmown contours. Murray's BELLOWING. G. Chappell seems to be... *smiling.*

And forty-five minutes after that the surviving Chappell hit in the direction of Boy Lizard Killer who'd moved again, now he was the only inner leg-side patroller. Ian Chappell... hesitated.

Seven-and-something hours the match had been going, Eagar gazing from behind his glasses and through the viewfinder at player after player as they walked on, every minute plotting, trying to wring from them some detail, what's the physical spark, what's the fiery kernel inside, that sums up this player today, with a hunch about which shots he had got so far but not really knowing and he wouldn't know until two evenings later in Kew, right on 5.30, once he'd waited for morning and driven to Kodak headquarters in Hemel Hempstead, an hour away, the only place in England that could process Kodachrome colour film, where he put the shots in a special envelope, stuck the envelope in a designated box, drove home, waited twenty-four hours, returned to Hemel Hempstead for the guaranteed 4.30 p.m. delivery time, swung the car around again, got back to Kew, and reopened the envelope. At the moment of the third Viv run-out Eagar was telling himself, "This is an historic event. The light's looking pretty good. Make sure you get some general views of the ground and crowd and scenery."

So: not only not anticipating run-out #3. "Dreading" a run-out. This was the crowd shot's downside. Slide your attention away from the play, you'll miss something. Consequently Eagar always kept his taking of crowd shots brief, kept a finger near his remote control

emergency backup. Though he did not on this occasion activate that option.

The camera and short lens in his hands took the photograph while simultaneously his "train of thought was going

> *I'm shooting a picture of the ground oh shit Chappell's about to be run out my best bet is just take it anyway..."*

The one with the outflung pointing arm in the picture is Rohan Kanhai at cover. Kanhai is directing Viv to throw to the wicketkeeper's end because the batsman going that way, Walters, is barely into stride. Viv considers the other batsman, I. Chappell, 62 not out, the prize scalp. And rejecting Kanhai's sound logic that's who he runs out despite the trickiness of the manoeuvre – totally missed by TV. Sure the ball would beat Viv, the cameraman jerked the TV camera away, yanking back wising up too late to catch what went down. Viv's high-speed intricacies of thinking also eluded the news and specialist cricket reporters. All that exists, the sole proof, memorial and ghost trail, is this photograph by Eagar: a photograph of – purportedly – a ground, crowd, scenery. Which it is, Lord's like it can never be again, with, on the left, the ex-grandstand in

front of Wellington Hospital. Rows of spectators on the lower banks are sitting on grass, not plastic seats. What appears a brown-bricked building behind the sightscreen is a wall and an awning offering shelter for parked cars including, somewhere there, Eagar's blue Renault. No over-the-top fielding celebrations broke out. Just two mini-huddles, plus stragglers.

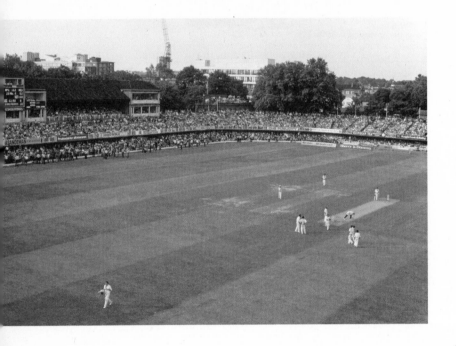

29 The art of the run-out #3 (epilogue).
37.6 overs. Lord's, 21st June 1975

The run-out is the comet high point of fielding. Fielding is a selfless, team-oriented function that invites cricketers to dive, swoop, circle and skitter, it is when their bodies are closest to the angels and to birdlife.

Fielding is the balletic element, capable of astounding, then it's over, and though names – Jessop, Pellew, Constantine, Donnelly, Endean, Bland, Simpson, Solkar, Boyce, Randall, Harper, Rhodes – may linger, few specific feats get written up or replayed but a fielder may, on performing a brilliant save, experience a knowingness in their limbs that this motion has been enacted before.

It is said that ballet is the bringing to life, on a stage, of paintings. A photograph of a run-out is ballet frozen.

Next to bowling or batting, fielding looks, and inside its own world is, a foreign sport.

The first ballet, *Ballet comique de la Reine*, premiered in 1581 and went for nearly six hours which is the traditional length, not counting refreshment breaks, of a day in the field.

Each day was like and unlike every other day, and Eagar's days never deviated far from the goal mentioned earlier, trying to make pictures to match John Woodcock's words in the *Times*. "That," Eagar says, "was my ambition, to illustrate what he wrote," and I am reading aloud something Woodcock wrote in Monday morning's paper after the World Cup final –

Lloyd made the pitch and the stumps and the bowlers and the ground and the trees all seem much smaller than they were.

30 Outfielder – Clive Lloyd – at Lord's, 21st June 1975

"That pleases me, yes," says Eagar.

For the last time in this longest day Eagar had moved – down to the grass, anticipating the post-match presentation, which was to be an affair attended by royalty. A Press Association photographer was contracted to shoot the presentation in black-and-white ("Interestingly, the guy decided it was dark enough to use flash") for immediate widespread release. Eagar had permission to do it in colour.

Until the presentation he was vulnerable. The match was not over or certain. Fifty-nine to win by the last pair, Thomson and Lillee, no longer felt crazy now they'd wiped off 34. The ball before, Lillee was caught off a no-ball but the crowd did not hear "no-ball" and invaded. Eagar was stuck far from the din without his long lens. Without his remote camera link which was next to the long lens at the top of the pavilion where he'd left them. Finally police pushed the groundstormers back. All Eagar had was short lenses and his only churning thought was "I'm in the wrong place" when in front of him, for a handful of seconds, ready to walk in with the bowler upon resumption, the captain of West Indies appeared – "he was within talking distance. I doubt," says Eagar, "we did talk. He was under pressure."

The batmaker's logo on Lloyd's back trouser pocket is fraying.

Lloyd's hands are beautiful. Fielding, a player can be invisible. Usually when attention was on Lloyd his hands were under batting gloves. There was little

seeing into his eyes. Foggy-seeming goggles left only the whites visible sometimes. Prospective lovers look at hands, they ask of themselves "Do I want to be touched by those

hands?", among other questions. Lloyd and his hands have been painted. The painting hangs at Lord's in the Long Room but in the painting Lloyd's hands are, disappointingly, a regular man's regular hands. In fairness to the artist, hands are hard to draw or paint, and a gift to photographers. Lloyd's hands are huge. They held together the players of many Caribbean island nations under one flag, and his family after his father died when Lloyd was fourteen. Handsome hands with a female following on seemingly "every", his longtime wife noticed, "continent". In Lloyd's time cricket was only played at the highest level on four out of seven continents. How fundamental, but rarely photographed, is the bodyshock as the hands of a fielder prepare to intercept and clamp round the ball. Beldam was aware of it. Photographing fielders was difficult before digital cameras. You had to focus in advance, hope the fielder did not move much, follow him for hours potentially with no guaranteeing when a ball may come near, meanwhile missing the bowling and batting action. A pho-

tographer might risk it at a minor game and even then discover something more profitable to shoot. Lloyd's mother, Sylvia, had big hands, like a marbles player's

1973 Lloyd in the covers. By Patrick Eagar
1904 A.E. Trott at second slip. By George Beldam
1969 The Queen & Lloyd; →
Ali & Lloyd →

hands, powerful knuckles. So big were Lloyd's hands he batted with four rubber grips round his bat handle. Some bowlers claimed it was not four grips but six. Most players just have one grip. But when Lloyd batted with one grip the bat slipped in his hands. He had big feet and long arms, long enough that he once trod on and spiked a hand fielding. It is his hands that fascinate. "Broad as a pair of paperback books" noticed his biographer, Simon Lister, when Lloyd, in his sixties, plonked them on a hotel reception desk while in conversation with the concierge. As captain, the handshake with the opposing captain before the coin toss was part of his job. Lloyd's hands also shook hands with Mandela, Ali, and the Queen of England, they were capable of deference, and delicacy. Minutes after Eagar's photograph, Lloyd's hands like pincers engulfed the handles of the World Cup trophy at the presentation.

After the World Cup was over came the warm-ups for the Tests, then the Tests, the most gruelling and invasive test of a player while for Eagar a Test meant five days under a sunhat, or too often and errantly no sunhat, puffing little gusts from his larynx through his lips, sweat corroding the metal sidepieces on his glasses, the glasses as a result giving him a sore face, sun-shielding umbrellas a no-go because they'd zap the person behind's view, a loo dash during breaks, lenses

hot to touch, eyes deviating down at three identical shadows cast by his tripod's legs, the problem of how to keep deep concentration going. Maybe chance of a gulp of wine with lunch, maybe not.

Except the First Test at Edgbaston was windy and had eight rain interruptions. Also the ball went out of shape, a moment described on radio by Eagar's friend Arlott:

> Well now there's a genuine inquest going on between Umpire Fagg, Old, Arnold, Denness, in fact the only protagonist, the only debater, not present is Snow, and the debate, oh, waging serious...

> A dramatic gesture by Denness. "Oh dear," he says, "oh dear." Umpire Bird comes up, hands on hips. Walks away in great indignation. Takes the ball – looks at it. Nobody will even give him a price for it. And Bird is now apparently coming into the pavilion to see if he can find something satisfactory...

> Bird is bearing a gift box of wrapped cricket balls! Fagg is going to do it properly, you see, Bird didn't want them to have a new ball but Fagg has sent for a gift box...

Ah yes, this is a general debate. Marsh is keeping out of it. Edwards is going up there to safeguard proceedings, to see that no alien object is smuggled in the guise of a cricket ball…

A whole box is put on the floor. And Denness is invited to take his choice. I thought this was going to be a generous proceeding – Umpire Bird embarking on a harangue…

Six grown men. Standing round a box of cricket balls.

Umpire Bird is signalling – yes, more cricket balls, more cricket balls. Perhaps it's – not Arnold's birthday, is it?

…Anyway, it's one resembling the old one, if not the old one. They all look the same, anyway. Comes in, bowls, and that's edged and out. Well there you are. It was all tactical, and Marsh is out, caught Fletcher, bowled Arnold… 265 for 6 – better than a royal visit.

Seven hours later it was Marsh who caught Greig, a moment caught [24] by Eagar. Next there was a converging, a swooping, on Marsh.

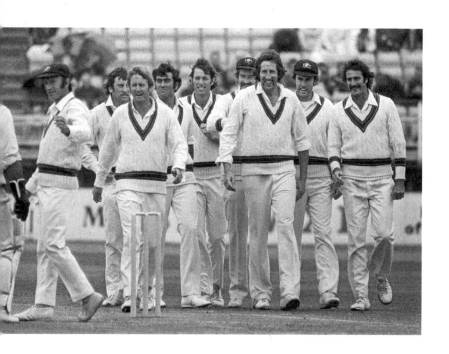

Nothing more than that: men – Marsh (wearing the glove), Walters (gave up cigarettes in 2009), Chappell I., Edwards (a TV exec-to-be), Turner (on debut, his bat hanging together by Elastoplast threads), McCosker, Mallett (the shy one), Walker (the goof), Chappell G., Lillee – men enjoying male company; their shoulders brush, hands almost touch, not erotic, just basking in the friendship, and the maleness.

Only one, captain Ian Chappell, seems distracted by thought, about the state of play or plotting the next batsman's demise while the rest are not thinking, they are feeling. Feeling not thinking is some kind of manifesto for their approach to cricket, but not only that, for how this photograph works. Not a photograph to be looked at and appreciated. A photograph that is felt. These aren't fit Ali-like specimens of pristine maledom. They are young men who look middle-aged, some of them, with craggy faces, shapeless bodies, not remote from the everyday, not butterflies behind glass. Many are the moving photographs in the world taken of a man but of men? Like this photograph? The semi-final teamshot [17] from three weeks back gets curiouser: not, perhaps, a mirror catching them. Catching some other unhappiness, unnameable, transitory. The ten men at Edgbaston [31] are so tight and so digging each other's company that they are missing the one who's missing, Thomson, who was fielding furthest away from the bat, and after converging on Marsh they begin walking Thomson's way...

Positioned behind Thomson on the fine-leg boundary was Eagar. Unexpectedly the fielding team started marching straight at him. He tried to focus. No auto-focus in his camera so he had to focus manually – pretty much a two-handed affair, one hand slightly lifting the

camera, the other hand altering the focus, and even then luck played a part: luck and hope. "Hope it's in focus," Eagar was thinking. The lifting/altering process was time-consuming. He couldn't fire away, shots by the dozen. He took the shot. In black-and-white. Sky was too dark to contemplate using colour. He attempted another shot but by the time he refocused the players were too close, he could not squeeze them all in. So he did not bother clicking. Best not to waste one. The photograph is a single take.

Eagar does not talk about it in the following terms or recall it this way but it was as if he had seen into them, these ten men. Somehow they were exposed to him, and after taking the photograph instinct not conscious thought propelled him to pursue further what he had glimpsed.

He was doing his job. Photographing the wickets and fine strokes.

But there was also this other strand. He had a five-day window, the Edgbaston Test, and once the Test was won the window might snap shut never for reopening.

The ten men photograph happened on the game's second evening. Early on the third afternoon a Lillee lifter rammed a twisting-away Amiss's left elbow

and crowded round the hurting batsman were eight Australians. But one was obscured and none, in the photograph, was looking in Eagar's direction. (None, either, looked sympathetic; one suppressed a smirk.) Eagar moved to the top of the pavilion. For some reason. And with a short lens shot ten, again, four slips, gully, short leg and a silly mid-on, silly mid-off, bowler, keeper. Sunday was a rest day. The Australians whiled a slab of the day away watching TV. The Open golf from Carnoustie was on. When the cricket resumed on Monday it was still only the fourth day's play.

They met Prince Philip and by a few minutes past three had achieved victory by an innings and 85. In between those two developments, it rained. Eagar crashed the dressing room.

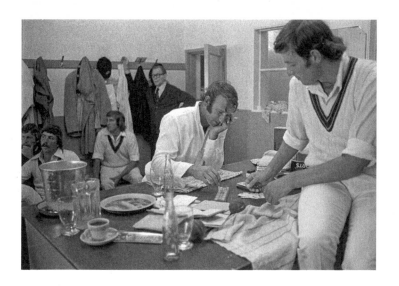

"Can I come in?"

Ian Chappell assented. Displeased was the dressing-room attendant. Eagar looked around, said "Ignore me", took in the banality: cards, trays, form guides, jugs, playing gear, going-out gear, a TV on a raised platform. Scorer Dave Sherwood. A cribbage board.

This is not a CCTV footage freezeframe. It's 1975. More a CCTV precursor. Quietly he weaved and took a stack of photographs, fifteen. Six focused on Walters, in the

middle, with the muttonchops and cigarette, but in the last five of these "Doug worked out what I was up to" and slid a pack of Rothmans into shot. Walters was a Rothmans company rep and cigarette addict with a serious turning-photoshoots-into-Rothmans-ads habit. Just this once [32] Walters was stymied – "I think," says Eagar, "it was what I'd learnt from Tony Greig, be quick."

On a bench, chatting, was Rod Marsh and, in a black turtleneck, Rod's pro-golfer brother Graham, smooth-shaven and elegantly dressed, a contrast to Rod, not that Graham was fresh off a plane from Milan though. From Carnoustie. Graham had finished sixth in the Open, on the TV on the platform, earning £3,000; Rod was on two hundred bucks a Test, more if Australia won, plus seven bucks a day for meals and ten for expenses; both nursed Swan Lager cans.

Eagar had gone into the realm before, when the previous Ashes series was won in Sydney. Australia partied loud that night at the team's Koala Motel before kicking on at the Different Drummer establishment in Kings Cross. Lillee autographed a woman's stomach. She did not wash. The signature was still showing the

following week. Before all that the media was made welcome in the dressing room. It was a photographic free-for-all but only two of that night's pictures keep a timeless lustre. "My photographs," says Eagar, "were no more exclusive than the *Sydney Morning Herald* ones with flashgun. The only difference was my Simon Guttmann education told me, look, it's not that dark. So the pictures I took were non-flash." Greg Chappell reclining. Ian Chappell opossum-eyed and spread-legged.

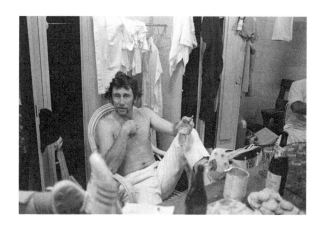

1974–75 In the dressing room #1 ↑ and #2 →
By Patrick Eagar

Eagar says, "Without flash they looked much more realistic."

I show him Mike Denness – taken moments after the 1975 Edgbaston thrashing, and shortly before Denness was deposed as England's captain for various small reasons connected to that thrashing and one large, central, glaringly logical reason with crumbs of dislogic at its core. This concerned the coin toss, which Denness had won. He chose to bowl first, and his teammates agreed, as it was cloudy so the ball should swing and seam. Instead Australia batted safely into the following afternoon, the ball scarcely wobbling, after which it was England's turn, for one over, rain fell, an early teatime was called, and a rained-on, uncovered, awkwardly drying pitch awaited England's batsmen. Weather forecasts had tipped exactly this rain and scenario. Denness had heard and believed in a different, local forecast.

All that and more shows on Denness's face: rough justice, humility, culpability, a bittersweet comedy.

The photograph states it better than the thousand written press conference postmortems did.

It puts in my head Eagar in Vietnam – "You said," I say, "you were never a good newshound" and he gives a small laugh, yet gentlemanly, like, you know it's trite to go transposing contexts and reading contradictions or a clear unwinding narrative into stuff that I say, right?

Denness said of the local weather people, They were wrong.

I tried, Denness said, summing up, to do a job of work.

We all make mistakes, said Denness, the last Scottish England captain.

"Is that a kilt?"

"No, I'm sure not," Eagar says.

"Looks like a kilt," I say.

"Oh." He stops. "I'll have another look." Spins away to an adjacent screen. Pause. "You're half right, he's wearing tartan trousers."

"Tartan trousers?"

"I would think not," Eagar says, "a kilt." Pause. Tincture of doubt, rising: "Doesn't really go with his blazer, does it?"

Three Tests remained, all draws, but rarely boring, loaded with passages of excitement, perversity, steel, Steele, flow, ebb, weirdness and virtuoso skill, it was just that the end always came too soon.

I show him Thomson in the Second Test, batting.

"I would put that one down as a probably-not-mine," Eagar says.

"But it's on page 70 of *Test Decade*."

"Hang on."

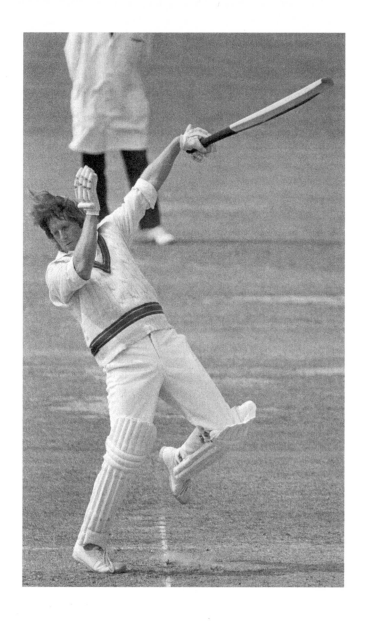

34 Jeff Thomson at Lord's, 1st August 1975

A creamy-pawed northwest London tabby cat with pricked-up ears and a pissed-off stare crept to within six feet of Two-Up Thomson while he swung a bat during net practice – and two days later Peter Lever bowled at Thommo's head at Lord's.

Lever grows wildflowers. He used to find, batting against Thomson, he could never muddle out what he should have done better. Any other bowler he'd replay the ball in his head. With Thomson he could not *see* the ball adequately for that.

Ball's out of shot in the photograph so body language is key. Angle of the elbows, hair standing on end, a "hands up!" posture of surrender, vulnerability written on the face, unhelmeted, and coiling-up foot all reveal that Lever has bowled a bouncer. On the back of Eagar's contact sheet is scrawled in brackets *Lever bowls bouncer.* An act of rebelcrazy-bravery skirting 1970s etiquette – because bumping a tailender was foul practice. And tempting revenge at the hand of Thomson later – and Lever had eight lives fewer to spare than the cat.

At Lord's a photographer could shoot straight-on or side-on and side-on there used to be a scorebox. Sitting right of the scorebox was an option, or left, about six people could fit in total, and Eagar when he was

shooting side-on always sat right unless he arrived late, which wasn't often, but for some reason, impossible to trace now, he has taken this photograph from left of the scorebox.

The umpire's head is cut off. And what is the worst fear in a batsman's nightmares about facing Jeff Thomson?

That you will lose your head.

It is as if René Magritte has borrowed Eagar's Nikon F2. The after-ripples are disorienting, violent.

"Revered, yet humble," the Barbadian photographer Gordon Brooks is telling me, "and so helpful to other photographers. I met Patrick in Barbados. Three years later he came up to me in Birmingham. 'Gordon,' he said, 'your turnout won't do at Lord's, you'll need a jacket, you'll need a tie' and that advice got me into the pavilion. All the other photographers languished downstairs. The angles he would get. I'd try copying him" – "Just another bloke who sat alongside you on the fence," Adelaide's sports photography giant, Ray Titus, is saying, then when play ended in Australia the photographers retreated to the local News Ltd office darkroom. "Us newspaper photographers," Titus says, "were renowned for being bloody slack. Not

slack. In a rush, you had to go, go, go and we'd have developed the film, printed up our shots, and he'd still be mixin' his chemicals and getting the temperature right. Getting it just perfect. Then the gloves would come on. Never a speck of dust would get on any negative, on anything" – "He could cut himself out of a conversation," Bruce Postle is recalling to me, "and talk to no one until lunchtime. Or till the teabreak. Just shut himself off and concentrate. I tried to do the same. Because he was such a mentor. I wasn't in his street, mate. And I remember sitting with our cameras and tripods and heavy 600mm lenses on the dog track, a track for greyhounds that went around the Brisbane Cricket Ground, which was the perfect place to be, looking down the pitch, and we all got up and had lunch. Came back and my camera was missing. A leg had collapsed and the camera fell over the back and crashed on the cement below and was lying in two pieces. He whipped down, got it. Reached into his camera bag. Fished out a smaller bag of screwdrivers and screws. For fifteen minutes Patrick Eagar sat screwing my camera back together. I tell other photographers this happened. They don't believe me."

In the quietudes and humdrum passages of the following fortnight Eagar pieced together, it is obvious now, a Lillee bowling action trilogy, although when instalment

#1 alights on his screen – the leap – what Eagar sees is mainly unavoidable stuff-ups and his own failure. "It is on one of the less good Kodak films. In order to get the speed. Taken on my longest lens and the one least able to handle small amounts of light. So technically it's," he says, "a disaster with the colour rather poor and it is a bit fuzzy and not as sharp as I would like although, on the other hand, the exposure time could have been no more than a 250th of a second, low for a fast bowler, yet you can see his ring, you can see the red ball, you can see it's definitely him. But there's loads of external movement and god knows what else. And the grass. It's that Ektachrome Kodak grass gone wrong."

In the photograph time is cobwebbed. It hangs. Like Lillee's feet in the air might stay up there. Indefinitely, and the umpire's neck's a tortoise's. Then in Lillee #2 – the delivery stride – what's stunning is the leg stretch. Pure pelvic propulsion that ripples up, gusts through Lillee, it pins his gold chain to his windpipe and slings kilowatts scudding down his bowling arm.

Eagar wanted next to recreate that pelvis hellstir in colour. To complete the trilogy. But now something else unavoidable foiled him: no sunshine. Without sun colour long-lens photography in 1975 was professional self-sabotage and worse, it was wasting film.

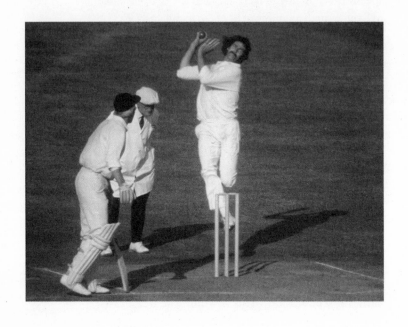

35 D.K.: The leap. Lord's, 2nd August 1975

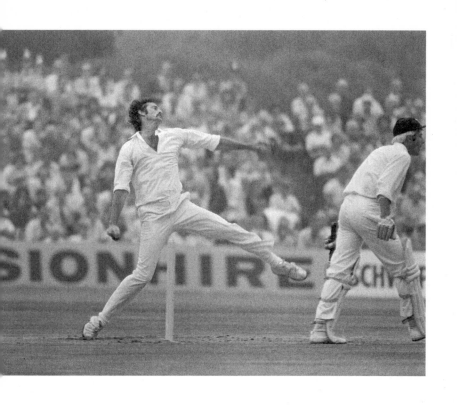

36 D.K.: The delivery stride. Headingley, 14th August 1975

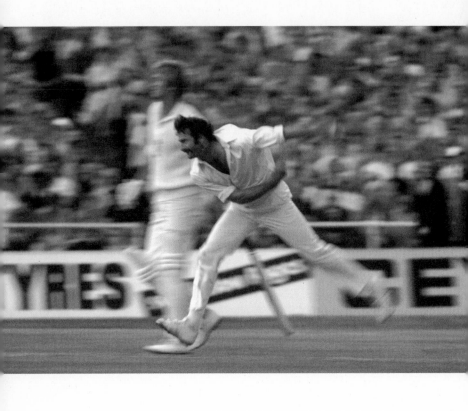

37 D.K.: The follow-through. Headingley, 15th August 1975

Stuck and frustrated in the murk, Eagar tried spinning darkness to his advantage. A thought came: "If I take a picture of Lillee using a very long exposure…"

In Lillee #3 time is sped up. It blurs.

"This is 1975," says Eagar now. "It's early days. But the Americans would have done it at *Sports Illustrated*. I couldn't have been the first to think about photographing an athlete. Photographing a sprinter. With a blur. I must have seen it."

Chi Cheng of Taiwan was once pictured jumping a hurdle in a rainbow blaze blur of legs, sneakers, spectators and wooden barrier. That was in *Sports Illustrated* in 1970. The blur effect then was rarely seen yet already old. At 1960's Rome Olympics a *Sports Illustrated* photographer let his camera slide onto Wilma Rudolph's lane before the 100-metre sprint. He followed her. Even after the race was won, and the race was hers, and the button was jabbed and picture taken and Rudolph was already decelerating he swung the camera after her in a clean and fluid arc. The resulting black-and-white photograph of Rudolph as her left arm collided with the finish rope is sublime. The thumb and four fingers are spread, and thrusting up; legs midstride are a diagonal blur; time is seriously messed with, everything washy with motion yet dreamily slow-looking. Mark Kauffman was the photographer who did it. Kauffman under his short-brim straw hat curling up at the edges

was a star photographer at the magazine. His fellow *Sports Illustrated* top dog John Zimmerman once photographed for *Life* a Detroit church's relocation. On log rollers the church was transported three blocks in four weeks. In Zimmerman's photograph, blurry, the church threatens to trample cars and elbow skyscrapers to the ground.

Always the blur's intent goes like this: to catch some essence the naked eye cannot clock. To heighten and multiply that essence.

Kauffman was determined Wilma Rudolph should stand out which meant, to his way of thinking, no stray practice hurdles in the background – seeing some, moments before the starter's gun went, he got up, abandoned position, shuffled along until the hurdles were out of sight.

No clutter of spectators in the background should be showing either. That was essential.

In Eagar's photograph, the last in his Lillee trilogy, a roily slipstream of fans, their heads the size of movie popcorn, sit with spreadout *Telegraph*s on their laps for

warmth, they're huddled in multicoloured fleece, a pair of binoculars are in there somewhere, and read and shredded in tatters around their shoes is a *Private Eye* that's a wind's breath away from fluttering, from blowing out onto the field, from becoming a minor menace. Perhaps Eagar could have angled or backlit the people out. And D.K. could have stood out like Wilma. But the man used to feed off the pulse and ruckus of crowds, who fed off him, and the photograph gets and in turn feeds off all that, how occasionally Lillee would push off a sightscreen's wheels with his boot heels at the start of his run-up, like he was pushing off the old backyard chickenwire fence. At those moments Lillee was playing with this thing that's between him and them, it is in the air. They see Lillee. They think about their own chickenwire pasts. They become suddenly conscious of their inner selves and stories, the ones other people, even their spouses, do not know. Lillee. Still with a decent mane on him. Hair today, going soon. Fielding on the fence, he'd give the fans the time of day. Sign hats and the backs of shirts and the strip of skin between the abdomen and navel on a woman. Be it soft or taut. He did not judge or discriminate. Kauffman once remote control photographed a steeplechase from the bottom of a hedge. Kauffman lamented that what he could not get across was the *sound* of horse hooves. Look at the Lillee photo. Shut eyes, listen. There's murmuring, a clamouring, rising, expanding.

Eagar had stopped subscribing to but was still monitoring *Sports Illustrated* by 1975 – "I think I subscribed for two, three years."

Two million a week was *Sports Illustrated*'s circulation. The photographs were as good as being at the game. Sitting on the sofa paled because TV shoved the fans not so close. Basketballers', footballers', baseballers' eyeballs: the magazine's pictures showed the exact direction they were pointing in. The number of days since a player shaved was calculable by stubble. Ugly raw human effort was depicted. When the Orioles' Brooks Robinson dived and caught Johnny Bench of the Reds it did not look timeless or classic. It looked hard. His elbows dug dirt from under Baltimore grass as he landed.

In Eagar's imagination all this was transferrable to his own sport.

A Ferrari driver creeping away from his on-fire Ferrari. Visible just out of a flame's lick: the shadow of the driver. Above and beyond that: Madrid's green outskirts.

Two middle-distance runners running, abreast, one's mouth open, the other's mouth laughing at what the other one just whispered.

In another picture a runner practised running across a sand dune landscape. His footprints resembled moon scratches. The runner was a speck so sharply in focus that kicked-up sand could be seen rising in wisps from his feet.

The best *Sports Illustrated* photographers each swore by and thanked, in common with Eagar, luck, and another thing uniting them was the thing or feeling photographers seem to get when a photograph is near, like perfume on a sliding-by neck something buzzes their senses, a phenomenon which maybe is also tied to luck. But then luck worked the same way for Eagar as it did for Kauffman, Zimmerman, Leifer, Walter Iooss Jr and the *Sports Illustrated* crew. For luck to matter, you had to dream up the possibility of the photograph in the first place.

So they were all of them grappling with similar maxims and obstacles except that Eagar was living three thousand miles east of the others and specialising in one sport: cricket. Could those Americans have handled cricket? Groucho Marx went to a cricket match at Lord's once.

"You're over here on holiday, are you, Mr Marx?" an official politely enquired.

"I was until I saw this game," Marx answered.

Kauffman once photographed cricketers at play in England. He positioned his camera between a tree's leaves. He could not get past the village cliché. He painted cricket as the somnambulant game.

Leifer's least favourite sport to photograph was base-ball and his main objection went – "What do you do when nothing happens, because so much of the game nothing happens?"

There are no Neil Leifer photographs of cricket.

"The Americans had access to every lump of equip-ment you could possibly buy and I didn't but I, if you like, aspired to that," says Eagar. "They used a thing called a Hulcher." Which was a motion-picture-style camera with rapid-speed shutter capabilities that could fire a hundred frames approx per second or – with some shrewd rejigging and disabling – 320 expos-ures. Appearance-wise, the Hulcher resembled a black swan implanted with Dalek spare parts. Zimmerman's pipe, which he smoked while working, used to dangle at an angle aslant from a boxlike structure at the Hulcher's rear.

Eagar says, "No way could I afford to run a Hulcher with cricket because of the enormous film consumption. If you were using a Hulcher for a golfer's swing, say, and you put a decent golfer up, one swing and you're done. Whereas with cricket if you're trying to get a batsman's cover drive you might have to photograph every ball for ten overs." That was equal in non-Hulcher language to 166 rolls of film. "It just wasn't feasible with cricket." Eagar did briefly, laboriously rig up a cinecamera and experiment with 16mm cinefilm. Sixty-four photos a second. He recorded a sequence of India's left-arm slow spin genius Bishan Bedi bowling. "I think you can look it up on my website."

In a tedious and long what-cricket-is piece for *Sports Illustrated* in 1973, novelist John Fowles singled Bedi out: "He never quite pitched the same ball twice...Bedi was a perfect example of cricket's only too frequent unwatchability to all but other cricketers."

Leifer once hung tight to a Hulcher while sloping forward on a ladder to capture diver Micki King back-flipping into a children-filled pool from thirty feet up. Zimmerman planted remote-control wires under the ice and cameras inside the goaltender's cage for the ice hockey at Madison Square Garden. Leifer, with a Hulcher, lay flat on his back on Idaho snow as two monoskiiers jumped over him. Zimmerman used

to insistently ski the slopes twice, for research, before shooting them; he wound up a skiing addict. Leifer photographed the Boston Marathon from a rented cherry picker crane, the Monaco Grand Prix from a TV tower, the America's Cup from a Goodyear blimp, the baseball in Houston from a gondola 208 metres above the playing surface. Leifer, in Minsk, sprawled under a pole-vault bar at such an angle that the pole vaulter looked to be leaping into an adjacent Vladimir Lenin mural. Leifer shot Shea Stadium at sunset from a chopper dodging planes and hovering in the approach path to LaGuardia airport while he waited for the sun to sink, redden and look pretty. Zimmerman turned pitcher Vida Blue into an octo-armed flamechucking Blue by ripping sections off a Hulcher's shutter to achieve a freakout twin short/long exposure effect. Zimmerman, underwater, put lighting in giant fishtanks then held his breath so as not to release bubbles, having been denied scuba equipment because that too could create bubbles, in order to document diver Bob Clotworthy's impact on still water. Leifer paced poolside in a Beverly Hills backyard for a Mark Spitz close-up. Zimmerman, in the ice hockey instance cited earlier, couldn't help noticing that as the game wore on some ice got shaved away, exposing the remote-control wires.

One player tripped over.

"Hey, Strawberry!" Muhammad Ali used to shout out as a welcome to Leifer, a redhead.

Leifer had an assistant with him often. Such as at the many fights where he photographed Ali. Far from reverse counting shots remaining on a film and ad lib ESP-ing whether to switch rolls now or risk missing something later – far from Eagar's reality – Leifer had an assistant preloading two backup cameras for whenever he required with whichever lens he desired. Still Leifer was a worrier, taping up bits of his camera that could potentially lurch or jerk to ensure they wouldn't. Leifer was methodical. He prepared thoroughly; yet for him, sports photography beat portrait shots because on athletes' faces the concentration was not something pre-prepared. It just spilled. Unrehearsable. A face betraying concentration has a tendency also to show signs of emotion. Sometimes Leifer was the emotional one. At a stars & stripes flag-raising at one Winter Olympics he got goosebumps.

Here is one of 1975's mysteries – no Hulcher, small budget, few luxuries, no assistant in his corner, and cricketers were stepping out of Eagar's photographs like painted known, reviled, admired characters in some century-old melodrama, which is what and who they were.

Ten years, twelve weeks before Eagar took his Thomson action photograph [1] Leifer took its prequel. It's spring training in 1965 and Giants pitcher Juan Marichal has got a kick like a cheerleader. Marichal's at maximum windup point. About to sling a ball down. His front leg's kicking towards vertical, the pitching hand's at five o'clock. Closer to six maybe. It is one of Leifer's most arresting images, it slays the senses on first viewing, it's very unmistakably not a Patrick Eagar: Marichal's eyes are hidden. Along with any facial contortion that's happening. Because his back and butt's to camera. As such the photograph is nearer to Eagar's flip-angle Thommo [2]. They're almost sister images, other than Thomson's wrist being dramatically cocked and Marichal's not, and the stumps in the Thomson picture, the spikes on Thomson's soles, the hair (Marichal's is contained under his baseball cap), the rippling proof of velocity on the back of Thomson's shirt, Thomson's wild peep over his left elbow.

In the Marichal photograph, Marichal has the higher leg kick. But then Thommo in the original Thommo photograph [1] is pretty much a two-legged miracle of creation.

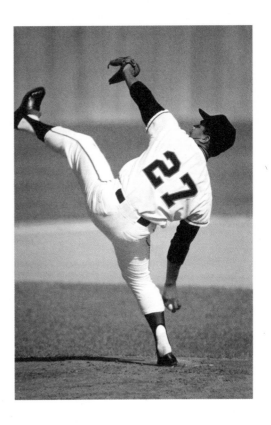

1965 Juan Marichal at spring training. By Neil Leifer

Tech wizardry and immense technical proficiency can put a distance between a photograph and the person looking at the photograph. Distance and a coldness. The looker is aware of an extra person, the photographer, or fragment, the photographer's ego, in the frame. Even emotion-laden photographs are tarnished: the emotion looks faked, cheap. Eagar's photographs make you stare, make you acquainted with and like you feel you know the people in them. They are about the subjects. About the work itself. And no extraneous force gets in the way – no news angle he's pushing or required to get for an editor. There is an egolessness which is what gives Eagar's photographs their vibrating warmth truth myth love core.

The nearest American approximation to Eagar is Kauffman and his melancholic photographs of golfers and their shadows on fading-light golf courses. Shadows of trees and rises, between which golfers may step. See, in Kauffman's photographs, the ball's shadow roll to the hole.

Kauffman said, "You were a kind of sorcerer, standing in the dim red glow of the darkroom and summoning a print to life in the chemical tray."

And Eugène Atget, in the early years of last century, wrote on the backs of photographs he took of old Paris's fountains, gargoyles, lion's-head doorknockers and stairway banisters – "will disappear".

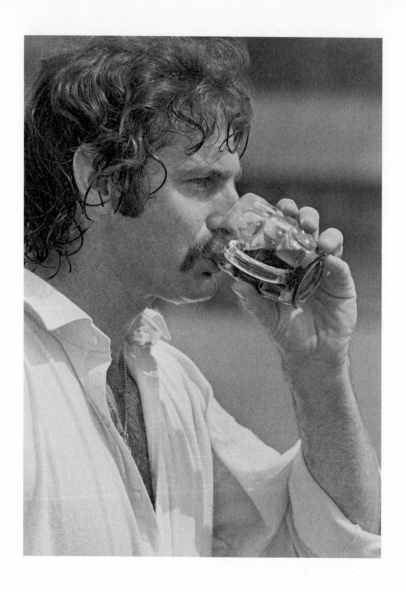

38 Lillee slugs a Coke, Lord's Test eve, 30th July 1975

1974 Buffalo Bills lineman refreshes at Shea Stadium. By Neil Leifer

1976 **Boy Lizard Killer by Patrick Eagar**

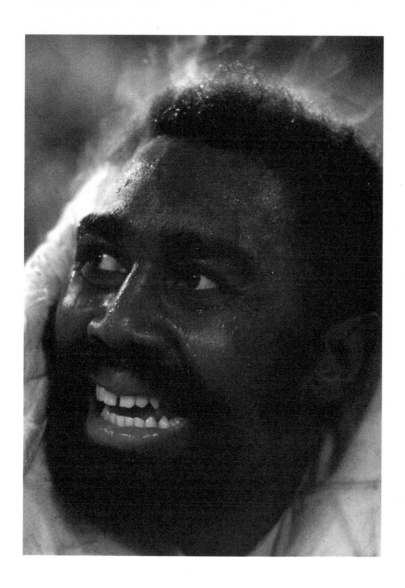

1971 **Bob Brown, Oakland Raiders, by Neil Leifer**

Late one morning before Eagar broke off Skype to make soup and while he was awaiting the delivery of two Ikea bookcases to go in his emptied-out – he had just sold and offloaded his archive, every print, negative and transparency, to Popperfoto in Northampton – and soon-to-be repainted office I said, "So you were married about seven months before the moon landing, right?"

"Right. We were in the flat in Richmond. My wife, quite interesting, one of her jobs was for Chatto & Windus, the book publishers, and I have a letter somewhere, I've seen it, I'll find it one day, it would be quite nice to have it, from Leonard Woolf" – author, publisher, Virginia's husband – "to her on the topic of her engagement."

I ask what his wife's job was and he says she was a secretary and an assistant. He says her boss Norah Smallwood was London publishing's toughest woman, much respected, widely feared, but sweet and she'd lend them her country cottage on weekends. "And what was the gist of Woolf's letter?" I ask. "Sort of congratulating her on her engagement but hoping she wouldn't be leaving the job," he says. Which she didn't, not until after the birth of their daughter, Kate, followed by a son, Will, who were aged two and coming up to one in the summer of 1975. After Chatto & Windus she worked for a West End impresario and helped a well-known

journalist specialising in Africa put together an annual Africa book. "Rather like *Wisden*," says Eagar, "but political, and I think by '75 with the children she was beginning to wonder what's next and I said 'Come and work for me because if you have to collect them from school at three, I'll understand.'

"So she did. She worked for me until she got ill really, in '94, '95."

He turns to talking about their house in Kew with the partition, darkroom, space for a tiny office, and we are interrupted. Two dogs yap. No, the novelty doorbell –

PE: "You OK there? They won't worry you."

Deliveryman 1: "Hello, sir. Ikea."

PE: "I've no idea how big this package is."

Deliveryman 1: "It's two hundred and – um – forty-five kilos. Just print inside there please, sir."

Deliveryman 2: "Morning, sir."

PE: "Hello, right, here we go. How easy is it to put all this together?"

Deliveryman 2: "Ah couldn't tell you. Ah only carry the stuff. Lovely place you've got."

PE: "That's kind. It's looking good on a day like today."

Deliveryman 2: "Ooh you're into cricket?"

PE: "Yes."

Deliveryman 2: "Ooh."

PE: "Are you interested in cricket?"

Deliveryman 2: "Ah know a bit about it. Wow."

Deliveryman 1: "Um, I'm trying to think of the umpire. Dickie Bird!"

PE: "Dickie, yeah, there we go."

Deliveryman 2: "You know im?"

PE: "Mad. Mad as a hatter."

Deliveryman 2: "Wha's your name then?"

Deliveryman 1: "He's Patrick."

PE: "Patrick Eagar. I take photographs."

Deliveryman 2: "Do yer?"

PE: "I did that one."

Deliveryman 1: "That's im. With the finger!"

Deliveryman 2: "Ah 'xpect you've actually travelled the world too, sir?"

Annabel, his wife, died at fifty-one on December 24th, 1996, of cancer.

They met as teenagers through his sister and got together after Cambridge where a total of three ladies' colleges made for a man/woman population imbalance. Twelve to one was the ratio. But Addenbrooke's was nearby, a big hospital with nurses.

"After Annabel died…"

He was fifty-two. "This isn't for publication particularly but the last time I had been totally on my own was the twelve-to-one days. I tell you, when you get to your fifties and you eliminate, say, the men who have died, and the couples who ended up divorcing because the husband has decided he's gay, which covers quite a few of my friends – a woman I saw for coffee this week who was at school with my sister, and with my wife, she

and her husband were happily married I thought for twenty-five years and he decided no, he's going off, not interested in women at all, she took it hard – suddenly the proportion of eligible men drops enormously. From twelve to one. To something in our favour. Interesting period, in a way. Anyway I was lucky" – in 2000 – "to meet Caroline, who's absolutely lovely, she's super."

Eagar's mum, Marjorie, Patrick has her face, lived thirty-five more years without a man after his dad died. "Something made her cross once. My mum completely lost it with my dad and threw an orange. From short range. Of course he caught it" – Desmond was an intrepid short leg. He'd field there in a Harlequin cap for head cover. She lived to ninety-three.

"How will I put it? During summer he was away a lot."

One summer Desmond broke a thumb batting. He missed three weeks' cricket and instead of the annual Eagar holiday happening without him in Paignton, a Devon seaside resort where Eagar's mum's mother lived, they went to Worthing. "First holiday we'd ever had with him," says Eagar, "in a hotel, by the sea, where Hampshire usually stayed when playing Sussex. So my father was quite well known there.

"Just me and him and my mum and my sister, and we just had a family holiday, and it was – different. I don't know what we did. I should think the English weather was foul and we sat freezing eating ice-cream. But it was a change from Paignton. The hotel wasn't posh. It had a bar in the basement we used to go to before the evening meal and in the bar was a fruit machine, a poker machine, which took old English pennies, that was the currency of the day, and I think we were allowed one go each in the evening but one morning my sister and I crept down armed with a couple of pennies that we had. She hit the jackpot. Seven a.m. and pennies went flying out onto the floor of the bar. Making a hell of a noise. I think somebody came down. Said what's going on here? My dear sister had seven or eight shillings' worth. That was in the bar smelling, as bars do, of beer the morning after and probably in those days cigarette smoke as well." Cigarette smoke floating: bad for health, great for photography, old boxing photographs especially. "And we had just crept down there together…"

Around a cricket field once somewhere young Patrick heard word spread. "Eagar's signing!" "Eagar's signing!" His father was a reluctant fulfiller of autograph-chasing

boys' hopes. One boy chirped come on at "Des" who replied "don't call me Des" and then "oh why not?" – so said this boy – "the *Daily Mirror* does." Listening in was Patrick. He was thirteen when his father stopped playing, staying on as Hampshire club secretary. Every lunchtime they'd see him. Desmond made the five-minute drive home, Marjorie cooked, Desmond immersed himself in stamps, Desmond drove back. Stamps were one of two collecting hobbies he had: cricket books/cricket documents/cricket contractual letters and the like was the other. After a teabreak once Patrick spied him in the Southampton back office. He was counting the day's takings. His worry was passionate for Hampshire's and cricket's wellbeing. Later he'd have deposited the takings at the bank on the way home. Umpiring a low-rank game once he fired Patrick out lbw and conspicuously did not praise his son who leapt after bowling a ball and a tough caught-and-bowled chance stuck. "But I think," says Patrick... "oh. Hell's teeth. Umpires are neutral." He was like the steelmaster Essington Lewis on whose wall was framed: I AM WORK.

I AM CRICKET. But no sad tinge, nothing bitter-sounding, creeps into Eagar's voice during his telling of memories of his father. Eagar is conscious that "I probably did the same to my children" and knows of

some summer holidays that went ahead without him. "Although until they were in senior school we always tried to go away at the end of the season. In September we'd have a week by the seaside – a bit late perhaps in England, September, the weather's already begun to crack up."

Writes the poet Anne Carson, "You know how they say a Zen butcher makes one correct cut and the whole ox falls apart like a puzzle."

That was how it was for Australia's top-order batting when Phil Edmonds bowled for the first time in a Test match: at Headingley, the Third Test, 1975. A slow attacking left-arm big spinner of the ball, Edmonds was also self-reliant, disputatious and highly educated, alarming-looking with a long head and bumper bar forehead but in a handsome way. This Zen butcher's knives were not sharp. His eighth ball in Test cricket was a long hop, tempting a hook stroke out of Ian Chappell who had a mild hooking addiction though not usually against the spinners, and his ninth simply went straight – Edmonds argued there was some in-drift – Edwards jabbing his bat confidently aloft and opting to play the delivery with his leg. Hook and miss, pad-struck, out, out.

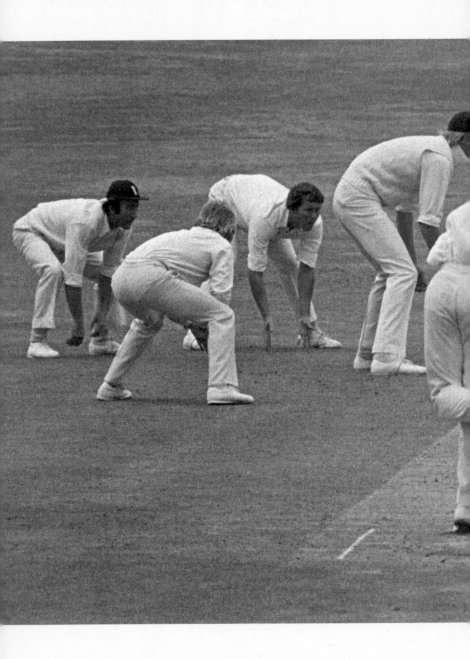

39 Hat-Trick Ball. Headingley, 15th August 1975

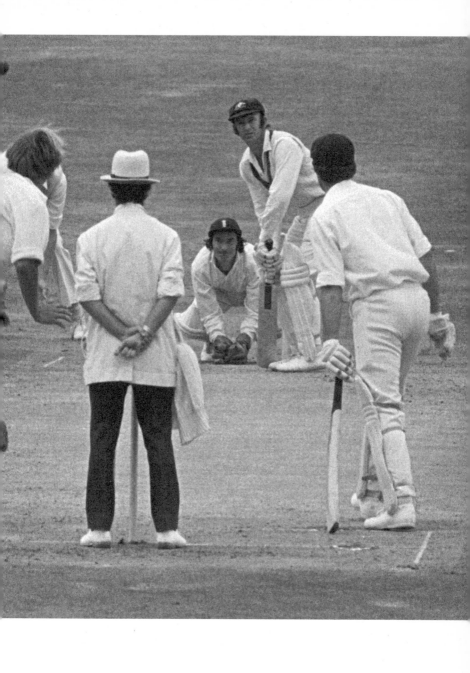

Phil and his brother Pierre as boys of seven and eight growing up in what is now Zambia used to walk out into the savannah and climb tall trees: forty feet high, fifty feet high. Afterwards Phil could not comprehend how they had done it. A key to this Eagar photograph is the moment it was taken: the moment when *anything's possible*.

The standard action photography thing to have done would be to capture what happened next, either survival or a historic hat-trick, both guaranteed anticlimaxes compared to what is transpiring in this photograph. Where anything's possible. The photograph is intimate. It feels tense. Knott, the wicketkeeper, feels this. His face is impassive but puffed-out cheeks tell of strain. Second slip John Hampshire's fingertips are actually touching the grass. Point fielder Fletcher is ready to catch with the backs of his palms. Greig, at silly point, is menacing, huge; Walters, the batsman, appears shrunken. Standing too far back. Did Walters normally dip at the knees like that? Choke the handle so low? *Fear* that's inside him has been put there by a bowler who is *slow*. A small obsession among cricket photographers is getting the entire fielding eleven in the frame, Eagar calls this

the "holy grail", and he has done it occasionally, though the photographs themselves tend to be merely objects of curiosity, no match for what is happening here where the not-happening-ness is everything. The seam of the ball is upright. But the ball has not yet landed or even begun its descent. It could turn, go straight, pitch wide, not bounce, Walters might attack, defend, get caught between modes. The ball is just *floating*.

Eagar agrees roughly with this assessment but is not happy. He sees too much grain in the photograph. It's a botched darkroom job, he thinks. The whites are not truly white – "Cricket's a bit like weddings," he says.

Walters survived.

Edmonds, whose teatime figures read fifteen balls, no maidens, four runs, three wickets, started towards the crease with a five-step glide on days like this. With every step, each foot seemed to take its time lifting. Higher he was all elbows and perfect angles, his fair hair bouncing. No acceleration, as the run-up was about getting rhythm, smoothness. Power came from the arm: a spraypainter tracing lines in blue sky. His bowling action was as easy as a children's rhyme, and if only a small thing went bad, everything could

be horrid, which meant there were other days when Edmonds could not land the ball at all, or else stop it from double bouncing, sometimes both in the same spell and with no understanding of why either kept occurring. One cold afternoon he left the field with a chill on his back, and eight days later when he bowled again the ball misfired and nearly knocked out first slip, only some sharp wicketkeeping saved this, and a few weeks after that, as acting captain, he won the toss and for ten minutes was torn: should he bowl or bat? Probably disposition, anxiety, not pure mechanics, came into it. Days happened when he forgot which foot in his run-up was supposed to go first. So he'd have no run, or he'd roughly halve his run-up and slow it to a crooked trot, twitchy, with a kink at the end and a broad white sunhat on his head sometimes, if it was night, daytime, whichever.

Those spells without a run-up when Edmonds with his strong arm delivered from a standstill were rare cases in history of a bowling action's elimination. The action exists to get the ball from hand to pitch with anything lethal that happens happening after pitching. With whatever a ball does having been done before. In some rung of cricket, low down or high, sometime. Yet the

way – the action – is never the same. Along comes a bowler, now and then, reminiscent of some famous predecessor. Then the minute you compare, their tics and distinctions outnumber the banal resemblances.

No two bowling actions are alike. Each bowler's action is as individual as his handprint. This is cricket's greatest strangeness.

Around this period of his career Eagar used to marvel at how endless were the variations and during a session at Southampton he had Alan Hurst's bowling action on the brain. Hurst hadn't played a Test in two years and wasn't a TV regular but Eagar must have twigged something, or dreamed something, in the flesh – a moment: an adrenaline-spilling, air-abseiling turbo moment of kite-hawk grace shortly after Hurst let go of the ball. To get the moment, Eagar would have to ignore the main play and focus a long lens on a blank space a dozen feet past the stumps, not knowing if he had got it until the film was dunked in the chemical tray and, should he have missed it, not knowing whether that was his own failure or if maybe Hurst simply did not do it every ball. Bowlers weren't like clocks.

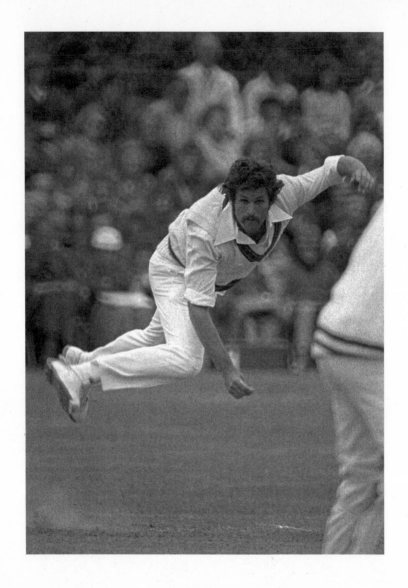

40 **Tour game – Alan Hurst bowls, 28th June 1975**

Hurst saw the picture and said, "Is that me?"

Which was a normal thing to say. Bowlers do not bowl in front of a mirror.

Also, this is a camera trait: to throw up a fragment of ourselves we do not recognise as us.

"How do you react to seeing yourself," I ask Eagar, "in photographs?" and he says "Not hugely well" and, laughing, shows me an oil painting a friend Reg Gadney did of him in front of the media centre at Lord's. It is a side-on portrait; Eagar's ear is smaller than in the real. In real life his ears are just normal.

"I think I prefer the painting to photographs," Eagar says, and then he switches to talking about Vietnam and how the cartoonist Gerald Scarfe was there at the same time. "I watched him. He would sit with a pencil,

a notepad and he would sketch a person and as the sketch slowly developed I'd be going my god, so lifelike. He had picked up on a moment. A feature." Scarfe's way was to then exaggerate the feature. Turn it to caricature. "But he started with a feeling, which he had absorbed over time," and now Eagar sidewinds once more to telling a story about the *Sunday Times* sending him to photograph Philip Larkin when Larkin was "well regarded, well published but not famous in the way he is now. I was more or less told to go off and take a picture of a librarian, which is what he was, in Hull. I bought a book of his poems, *The Whitsun Weddings*, and read it on the train going up."

(Larkin's poem of that name, "The Whitsun Weddings", records scenes through a train's window –

An Odeon went past, a cooling tower,

And someone running up to bowl…)

"At the time," Eagar says, "it was an interesting day out.

"But I think – I wasn't happy with what I got. The film came out in the darkroom. There it was. I remembered somebody, and what I remembered wasn't in the photos."

Only skin is the level at which the realest me may lurk. Skin to skin, you can glimpse it, sense it. But try to trap it, to contain it. It's not there. Not on the grain of the paper on which the photograph is printed, or in a screen's pixels. Only in a different dimension. Drawings and paintings can get close. And photography can be, as Eagar puts it, "quite frustrating". Some quality, some look, some fraction-of-a-moment air, some way of being stays elusive. And then there's the annoyance of how a photograph of another, of some genetic relation, can shove back in our face a piece of us that is also in them but which, before seeing this photograph, we would not have recognised as us; it's a far from uplifting realisation. (My dad as a boy on a tractor.)

"Even while we're talking," Eagar says, "there's a picture of me, the me you're seeing now, in the bottom right-hand corner of my screen." That's a Skype interface thing. "How do I feel about that? I don't know. Can you see you? I can sort of put up with the image in the mirror, when I'm shaving, in the morning, think 'god that's looking older'. But the fraction-of-a-moment thing?"

He says, "When my grandchildren come round I think, well, that's a nice picture. So I take it. And it's not."

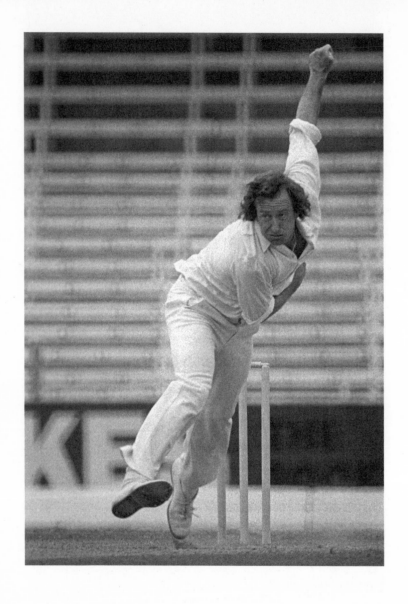

41 Graham McKenzie at The Oval, Surrey v. Leicestershire, 8th July 1975

Eagar went looking for the perfect bowling action. He was bound for Basingstoke the next day, Birmingham the day after, but this day his diary had a hole. With a county game near home headed for a tense finish he got in his blue car. Graham McKenzie was considered the perfect bowling action's owner. It was the ten-step lope of a giant cupping a circus ferris wheel in his hands and delicately setting it in motion. Frictionless. And when he appealed to the umpire, McKenzie's scream was *soundless*. Eagar had tried photographing McKenzie before but reckoned himself unlucky. It rained or McKenzie wasn't selected or picked up an injury or when he bowled Eagar missed him or the background wasn't right. Eagar always felt and still feels: "He was somebody I failed."

Something was elusive.

What he captured on this day – Tuesday, in London, no other witnesses, people had jobs or better places to be – was something else: headlong ageing. The finished-up sportsman. Late McKenzie. As old-seeming as some dry creeks. His furrows almost align with the rows of unoccupied seating. Battling assorted bugs and bodyaches McKenzie had likened a day's cricket to a factory shift (factory workers may quibble). His county Leicestershire would shortly, as goodbye, present him with a solid silver statue. McKenzie promised never, even on beaches, to play cricket again (a promise he didn't keep).

Here the statue is him. Any moment a gull may rest or crap on his head. Nat Fein of the *New York Herald*

Tribune photographed at a dark Yankee Stadium without a flash Babe Ruth who had throat cancer. Within two months the cancer had killed him. Ruth's uniform number was being officially retired and Fein wanted to get the 3 in the picture, so he took the photograph from behind, which by luck proved the ideal position to catch the tilt of Ruth's back, hinting at frailty, and at heavy feeling...

1948 The Babe Bows Out by Nat Fein

The McKenzie picture includes the eyes.

The eyes ask: "What's next?"

Fein took his photograph with a Speed Graphic, which was cumbersome and a gift from his mother.

"By the way," announces Eagar, three-quarters of the way, it's February, into one of our conversations – "It is Everton Weekes's ninety-first birthday today. I read it in the paper. It was in a section of the *Guardian*."

To take the Hurst bowling action [40] photograph –
see also [14], [2], [6] – Eagar used a small mirror lens,
most likely made in Russia although he had a Japanese
version too. Mirror lenses gave good quality and yacht-
ing photographers dug them because they made the sea
look sparkly and idyllic. "You could tell a mirror-lens
photo by the doughnut effect," Eagar explains, "the
background was all little round circles" – something
to do with one mirror being at the rear of the lens and
light bouncing off that mirror into another mirror then
squirting out through a round entrance near where the
light got in to begin with. The Russian one was good for
only three seasons, a blow, as the silver on the mirrors
decayed. Eventually Nikon made one that was longer
lasting.

Eagar's first camera at age twelve was a box camera
from his grandmother, who he'd asked four years
earlier, "Can I take a picture?"

She replied, "Oh. You wouldn't know what to do."

That was his father's mother. Film was costly to buy, pro-
cess and each photograph taken had a value attached.

His other grandmother came from a family of clergy-
men and this grandmother photographed churches in
Devon. She developed her own film. She turned the
pictures into postcards for sale. This was in the 1920s.

As church postcards go they were pretty good, thinks Eagar. "Later in life she didn't do it anymore so I never talked to her about photography."

At fifteen he got a Contaflex IV which his father bought duty-free at the port of Aden on the boat trip to Australia and "was disappointed, I think, that it wasn't going to take close-ups of cricket, he was rather hoping the lens would be longer." On his father's return the camera was Eagar's.

"As a photographer," Eagar says, "I was always brought up to not cut people's feet, heads [34] or hands off if I could help it."

"The Steve Waugh one" – page 15 – "wasn't the best photograph to be taken," he mentioned one Skype night. "I missed that. That happened a few balls before when Waugh was even further out of his crease and I 'saw' the exact picture. But I was using a 600mm lens and on the 600 I couldn't fit in Jack Russell, the wicket-keeper, I couldn't get *that* composition, so I changed to something wider but by the time I'd done so it wasn't as good as it was three or four balls before, this is all getting a bit silly/technical maybe…"

A question Eagar once asked his friend Dennis Oulds was how many shots in a day, in a hectic day, did you used to take back in the era of plate cameras? "And Dennis said, 'Usually seventeen.' Seventeen. One-seven. Quite intriguing. They were really disciplined. Restrained."

Eagar was averaging between 160 and 180 a day circa 1975.

Eagar's all-time record for one ball was forty-five shots. That was in 1976 on three cameras when Michael Holding bowled Greig.

On the remote camera, he'd aim each day for thirty-six shots max, i.e. a roll of film a day because "to reload the thing if I ran out of film I'd have to walk all the way around the ground, up a pavilion's steps, probably take me ten minutes, quarter of an hour to do that.

"I'd studied," says Eagar, "the work of the Americans" – Leifer, for one, had been draping 50ft fisheyes above strobe-lit ice hockey rinks and operating them remotely since at least 1963 – "...and I was thinking about remote-control cameras through '73 then in the winter of '73–4 I really decided, right, I am going to do something about this, and the next season I bought five

hundred feet of wire and went to Mote Park in Maidstone, it was an ordinary Kent home game, and spent the morning linking up...Hang on," he backtracks, "the other crucial thing to remember is this" – that motor drives round that time were more myth than an actual camera component, and it was only Eagar laying his hands on an early Nikon motor drive, built in America, not official Nikon product, fell off the back of a proverbial Nikon truck, that enabled him to get even this far.

"Anyway" – back to Mote Park – "I set up a camera on top of a TV gantry tower. With the wire attached to the camera. And I buried the wire in the mud. Sort of covered it over so spectators wouldn't trip then I unwound the wire right around the ground to where I was positioned. Took forever. Sadly a TV cameraman decided the camera, my camera, was not being used because no one was sitting behind pointing it. So he moved it. It spent half the day photographing the sky. I've still got the cloud pictures.

"I got enough input from that to go the American route." Radio wavelengths, he means. No more circumnavigations of cricket grounds with hardware shop wire.

"Except the UK government was prohibitive," says Eagar, "about wavelengths. Radio was used by police, the army. There seemed to be only a certain number of wavelengths out there. None for cameras – the nearest thing was model boats, model planes, whose radio frequency was 27 MHz. I remember it. And there was a chap, a friend of a friend or something, I forget, an amateur who was into electronics and as a hobby flew model aircraft beautifully, could take off, do loop-the-loop, go anywhere, and this chap fitted me up with a transmitter device. The range wasn't that good and it wasn't that reliable but it worked. Now everybody's doing it, they stick the transmitter for the remote camera on their other camera, so when you fire one they both go off, which isn't so clever because the point of the remote is you're looking to get a totally different picture only people now tend to put their remote camera facing down the wicket, shooting pretty loose, so you get slip fielders in the frame, you get a batsman/bowler situation, whereas in those days I'd plant them all over. I used to put long lenses square.

"Then for a few years I experimented with an infrared beam designed to work up to thirty or forty feet only but with the cunning use of magnifying lenses you could make the beam narrower, more powerful, and fire it across a cricket ground to set a camera off. In some ways that was more certain to work than the

wavelengths if you lined the beam up right. If it wasn't lined up it didn't go off at all.

"As part of the thank-you to that chap we'd install one of my cameras in one of his model aeroplanes and go out, fly it around. Like early drones technology."

In the event of rain at the cricket a plastic bag served as Eagar's unattended remote camera's shield. "Then a nice lady in Nottingham said to me one day, 'I could make you a waterproof cover that would fit over that camera,' and she did, and I used it for years."

Car parking was a breeze. At both The Oval and Trent Bridge he had a spot reserved and sat the Renault a few metres from where he himself sat with his cameras and lenses and gadgets and cases and bits and heavy pieces. Photographic passes, a sorer matter, were issued by the Test and County Cricket Board to the Newspaper Publishers' Association which had a Bouverie Street office where Eagar was required to go personally and fetch his pass from this one particular lowlife. "Sort of Dickensian, slightly thin, sharp-featured, mean. Named Vaughan? God he made life difficult," says

Eagar. "And it was on purpose. His instructions were that I was to receive a pass. But he took delight in insisting I apply to him, in writing, each match. The threat was I might not always get one as they were primarily intended for the national newspapers and international agencies. Not for freelancers. Always he kept me waiting. He had his own little empire and I was interfering because I didn't fit."

"To the other photographers you must have seemed," I say, "an exotic ambitious creature in their midst with your multiple cameras, with the remote one going."

"Yeah," he says, "probably, yeah", although people were accepting and a "proper beer-drinking, cigarette-smoking, everything else-doing Aussie" named Ron McKenzie was kind to him in Barbados and Trinidad on his first tour and that friendship stuck for life – simply, Eagar was an artist, without ever cracking phoney or pretentious-talking about his art, whose mind was not tied down by the period in which he lived or by the limitations of his equipment.

"Difficult to remember," Eagar says, "how little you could enlarge something in a picture and still keep the quality. The young ones starting out now include far more in the photo. If they want to crop it afterwards, they can, choosing the bit that they want. We were really taking photographs in extreme close-up. Quite tight pieces of framing they were. When it was at all dark, you couldn't take pictures, close-ups. The film was so slow, and the lenses. 'Obsessed' is probably going too far but I was always anxious to get the best possible quality which was why I'd use a long, long lens. Long lenses were small aperture. Even expensive ones were. Today you just shoot the whole thing in colour, digital, you can get away with one camera unless you want remote. In 1975 the best-quality colour film by far was Kodachrome 25, a new version of the dependable old Kodachrome II. It had a speed rating of ISO 25. This is so slow by modern standards that I know of no digital camera that can be set anywhere near that low. Some do make it down to ISO 64 but they are rare. Mostly they start at ISO 100. Photographing a bowler's action, you'd do it one day, if it didn't work, you'd try another day, whereas now they shoot a high-speed sequence, in the modern jargon they 'hose' it, then they look at the back of the camera, see what they've got, move on; it's all over in one ball. Before, everything

was manual focus. High error rate. Whether I'd wised up by '75 to having an earpiece in and listening to the radio commentary, that I don't know. Not necessarily. But probably, I mean, all you needed was a small portable radio, although they didn't always exist, and if I did have one on me then it was a question of whether or not the BBC were broadcasting that day. All these things taken for granted – wonderful earpiece radios you can buy inside the ground which tune you into the TV commentators – they're clever." Switching from *Cricketer* magazine to the new *Wisden Cricket Monthly* in 1979, Eagar was on a "fixed rate per Test and the deal was Frithy [the editor] could use up to seven photographs at any size he wanted. He didn't have to pay more for big ones. I hoped this would encourage him to use maybe two or three really big. Feature size. Which for him would have been good value. But he'd signed for seven, he was bloody well going to use seven, and to fit them in the space they were nearly always small. Go through WCM, count them, I'll bet you it's seven* plus or minus nought every Test. For ever. I think he felt I wasn't always quite happy." Laughing now. "Well, cricket's a great sport. There's a lot of photography to be done."

* Naturally some unnatural-shaped photos evolved out of this cropping process – one dogleg-right irregular hexagon, one skeletal vertical rectangle, three mini but normal rectangles, a near-square and a second irregular hexagon (plus a WCM necktie ad) illustrated the Trent Bridge '81 Test report. Great magazine though.

Per day: 180, 160. One-six-o. Eagar's daily average belongs to when digital meant people, owners of fingers. Eagar:

> With digital technology you can
> people do
> shoot every ball…
> ten pictures every ball…ninety overs every
> day
> five thousand pictures.

The camera is all-seeing. And maybe something has happened, a disorienting, a narrowing, to the quality of people's looking. Seeing is first dreaming the possibility of the thing one sees.

A ball's landing spot on the pitch opened Eagar's mind to strokes the batsman may play. Play-and-a-miss: this induced a state of hyper-awakeness. Fright on a face, or a batsman's flicker of a smile: clues. Glint of sun's yellow on a bail told Eagar that bail was jarred, about to fly.

Five thousand pictures a day getting stored on memory cards, instantly forgotten.

And the surreal thing was how time used to slow in those fragments of tenths of seconds before he took the photograph. On TV at night he'd watch the day's highlights. They did not compute. Too fast: faster than it had felt in the moment of looking, of concentrating. If it happened that fast how did he photograph it?

Edges were tough: no clues, nothing until the ball's oblique leap from the blade, followed by a gap, fleeting but it felt long, longer than the usual time sag, of him straining to keep his fingers still and not click too soon.

42 Steele hands, Headingley, 18th August 1975

Time can slow, it clogs, speeds up, a tango, out of sync
with the air, jutting and swelling misshapen as a snake's
belly when the snake has gulped a fellow snake. Snakes
and not only. The man in the gully who held the catch
in the photograph – Steele – had the look of sixty
years' hard life having been tipped into thirty-three.
Thirty-three was Steele's age in the photograph. He
was thirty-three on his England debut weeks earlier
when "bloody hell, he's very grey, isn't he?" was whis-
pered in the Long Room on his walk out to bat not so

softly that Steele didn't hear it. Then two Aprils ago at *Wisden*'s annual dinner – in the Long Room – Eagar saw Steele. But what Eagar thought he was seeing was a Steele lookalike. Each was forty-one years older, Steele and Eagar. Physically Steele was unaltered. Could it be him, Eagar even wondered. Eagar asked himself, how do people visibly age? He came up with: wrinkles, getting fatter, and hair that's getting greyer, receding, or both. None seemed to apply to this Steele, who was same as the old Steele. They talked, and part of their long conversation was about facing (no helmet: Steele slid a towel down a pant leg) Jeff Thomson, another time riddle, the rumoured time differential between the ball's passage and a batsman's capacity to react running to negative 0.162 sec. Just illusions. Steele was ageing, despite appearances, and one day will die, and how people feel when they look at the photograph will change. Photographs are not fixed things, not when they are taken, nor later, not ever.

Say Steele in the photograph was not standing so close, nine feet from the pitch in the old-time gully fielding fashion to cut down the angle and increase a ball's likelihood of flying at and reaching him. In that flipped reality no catch, no photograph, gets taken.

"As the day waned and the light went down the clouds *suddenly turned pink*. I had one of those momentary pauses where I thought, 'God, I shouldn't take this photograph. It's too beautiful.'"

2001 The North Wall. By Joel Meyerowitz

Joel Meyerowitz, whose dilemma this was, talked his way onto Ground Zero after the towers were felled and stayed nine months. Light energised this photographer's insides: thinking about light, responding to light, making photographs out of light. The summer after 1975, Meyerowitz was on Cape Cod, taking photographs for a book that became *Cape Light*, messing with a new force in photography, colour. Colour in a photograph was like looking at the world and into yourself. Colour – pink say – let you "retrieve emotions that were perhaps bred in you from infancy, from the warmth and pinkness of your mother's breast". Long before that summer Meyerowitz was photographing people on streets, already poking at the possibilities his camera presented him with. Possibilities of speed. "If you've got 1000th of a second," he reasoned, "then you should use it" – should test it and press it until it begs, yowls and breaks then peruse your contact sheet, see what the result looks like, so that this New Yorker who never shot a lick of cricket had the same preoccupations, similar worldframe, as a 1970s cricket photographer.

"Feelings," said Meyerowitz in a 1981 documentary, "don't take more than 1000th of a second anyway."

Eagar's photographs were a collaboration. There was the boundary rider, him, and across a fence, them. No rules were set down. How high was their awareness of his presence? Who held the power seesawed. They had obligations beyond their team. Obligations to history, to memory: if Eagar was at the ground they should put on a show. But was this, in their heads, ever more than a crumb? Did they realise? Bowlers could plot and strike poses. Could batsmen with the red blur rising at them? Which destiny's greater, hitting a 100 or 200 that's yellowing the moment it is over or to be the star in an Eagar photograph? Photographing a batsman, one he had shot countless times before, did he see the person, did he see past photographs he had made, did he see a version of the person, was this version filtered through his old photographs? These issues are not answerable in straight ways and dealing with them required of Eagar the same traits handy in testing wine, blankets, washing machines, nylon stockings. Eagar thinks that at *Which?* magazine he was "quite useful". What were the traits? Fast thinking, ingenuity, spontaneity, problem fixing, tech know-how, embracing of risk, imagination, belief/faith in chance.

One summer the photographing of the ballet mattered
more than the ballet. The Fourth Test was a bore draw
at The Oval that lasted a week, including the rest day
on Sunday, plus an extra day scheduled in hope of a
result, and late on the first evening, August 28th, when
McCosker was batting the light suddenly turned pink.

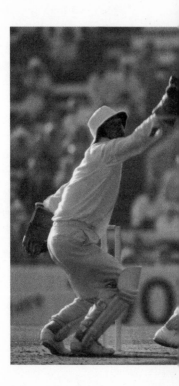

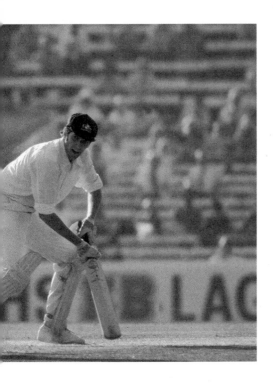

43 The Late Cut

Acknowledgements

First, to Patrick Eagar for time, adventurousness, kindness. To Billie and Miguel for joy. Rahul Bhattacharya – the believer; no book without Rahul. See you in Hobart/Assam. And thanks Shruti. David Studham and Trevor Ruddell for letting me in at the best library on my planet. Bob Thomas, for the gracious hunting and gathering. Jon Riley, for intelligence and great publishing gusto. Lindsay Nash, for excitement. Tanya Aldred, Mark Ray, Gideon Haigh, Clinton Walker, Andrew Hyde, Nathan Hollier, Duncan Hamilton, Clare Drysdale: comrades, friends. Georgina Difford, Rose Tomaszewska, riverrunners, all enthusiasm. Most, last, Maria Tumarkin. That is one stunningly intrepid woman.

Backnotes

Four books especially have stimulated me – Lawrence Weschler's *Everything that Rises* (McSweeney's, 2006) and *Seeing is Forgetting the Name of the Thing One Sees* (University of California Press, 1982), Roland Barthes's posthumous *Camera Lucida* (Hill & Wang, 1981), and Geoff Dyer's *The Ongoing Moment* (Little, Brown, 2005).

Additionally, the Boy Lizard Killer school feats (p.145) are reminisced about in *Viv Richards* by Viv Richards with David Foot (Star, 1979); "seventy-eight frames" (p.143) echoes the exact number of photographs taken of one Mitchell Johnson wicket celebration by the (excellent) present-day freelancer Philip Brown on July 17th, 2015; Roly Jenkins's "Spin for Roly" (p.116) negotiation with the ball is mentioned in Stephen Chalke's *The Way it Was* (Fairfield, 2008), which also recounts a day when Jenkins had a sore finger and said to the umpire, "I'll borrow the one you're not using." Shortly after, Jenkins broke down crying and took a month off bowling; the "No Ball Games" sign (p.93) where a cricket field once existed was spotted by Chris Arnot and referred to in *Britain's Lost Cricket Grounds* (Aurum, 2011); "almost like Beldam was thinking" turns out to be appropriate wording (p.11) because it's now known, thanks to Gideon Haigh's *Stroke of Genius* (Penguin, 2016), that Beldam achieved his reverse-angle version by

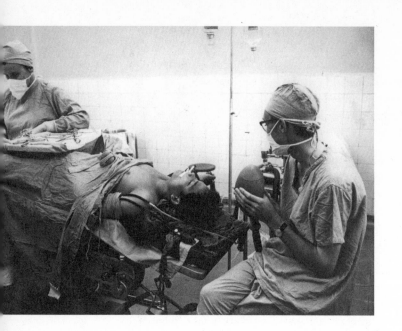

reverse process to Eagar – the Trumper-from-behind shot was taken ten, eleven or twelve days *before* the side-on masterpiece; Essington Lewis's "I Am Work" motto (p.208) outlived Essington Lewis by becoming the title of the last chapter of Geoffrey Blainey's *The Steel Master* (Macmillan, 1971); the Liberace quote (p.24) gets an airing in *Air Guitar* (Art Issues. Press, 1997) by Dave Hickey, who contends that the *Mirror*'s rant "in its little way, changed the world"; Arlott's "that boy" utterance (p.133) was heard on BBC4 on Arlott's seventieth birthday and reproduced in David Rayvern Allen's *Arlott* (HarperCollins, 1994); "Summer of the Spinning Tots" (p.91) ran in a Tim de Lisle-era WCM of May 2000; Turner's Elastoplast-to-the-rescue job (p.165) and his handing of his handkerchief (p.147) to Umpire Spencer were revealed in Peter Hanlon's "Something About Alan" in *Australia: Story of a Cricket Country* (Hardie Grant, 2011); the signature-on-the-stomach anecdote (p.170) comes from Adrian McGregor's *Greg Chappell* (Collins, 1985); the nun & the tomboy quote (p.78) is from *Court on Court* (Dodd, Mead & Co., 1975) but more insightful and way more entertaining is Grace Lichtenstein's 1974 account of the women's tennis circuit *A Long Way, Baby*; the maths (p.236) went 0.438 (travel time between Thommo's hand and batsman's bat) – 0.3 (time to see and mentally pre-map the ball then decide on a shot) – 0.3 (time to play the shot) = negative .0162 sec; for sorcery (p.197) made semi-explicable, see Zimmerman and Kauffman's *Photographing Sports* (Morgan & Morgan, 1975); Leifer said what he said about nothing (p.190) to Larry Berman and Chris Maher in 2002, and about movie directing (p.100) to Dave Mondy in the *Iowa Review* in 2014; the equivalent of the Eagar/B.L.K. twin-glimmer dilemma (p.28) for Dyer (op. cit.) is Edward Weston/D.H. Lawrence; Keystone

photographer David Ashdown saw and got a photo of the cat (p.178); eyes of opossums (p.171) and other small animals at the Antwerp Nocturama had "the fixed, inquiring gaze found in certain painters and philosophers", wrote W.G. Sebald in *Austerlitz* (Hamish Hamilton, 2001); especially classic (p.78) and deeply romantic is a passage in *A Handful of Summers* (Heinemann, 1978) about the Buding sisters and a feeling of weightlessness; the anvil line (p.78) owes everything to song three on *Calenture* (White/Hot Records, 1987); the photograph on the previous page shows Patrick Eagar in Vietnam in 1966.